"It is hard to imagine a better pairing of author and subject than George MacDonald, one of the essential Victorians and one of the deepest of Christian writers, and Timothy Larsen, one of our very finest historians. This book is truly a joy to read."

Alan Jacobs, distinguished professor of humanities in the honors program at Baylor University

"Rarely, if ever, does a theologian grasp the essentials of luminaries such as C. S. Lewis, J. R. R. Tolkien, George MacDonald, G. K. Chesterton, and Madeleine L'Engle. But here, in this exquisitely argued, beautifully crafted, and elegantly written thesis, Timothy Larsen offers a beguiling meditation on incarnation, doubt, and re-enchantment. With his careful and nuanced focus on George MacDonald, Timothy Larsen has produced a poised, sumptuous, and sublime theological essay—worthy, indeed, of Lewis, Chesterton, Tolkien, L'Engle, and MacDonald. This is Christian apologetics at its best and from one of the finest public intellectuals writing in our time."

Martyn Percy, dean of Christ Church, Oxford

"In this gem of a book, Timothy Larsen uses the delightful and moving writings of George MacDonald to open surprising new vistas on the religious world of Victorian Britain. I recommend it highly."

Thomas S. Kidd, distinguished professor of history at Baylor University

"In a Victorian religious culture saturated with religious preoccupations and moral anxieties, George MacDonald stands out as a relatively neglected author whose work nonetheless pays careful attention to the intersection of religion and literature. Tim Larsen brilliantly opens up MacDonald's imaginative writing as well as his sermons and essays to demonstrate how closely he followed contemporary interest in Christian doctrine and the challenges it faced in his day. No one who knows Larsen's work will be surprised at this: with wit, knowledge, and an acute critical intelligence, Larsen picks out again and again the ways in which MacDonald's fiction illustrated or experimented with controverted points of Christian doctrine, yet still functioned as good, readable fiction. A series of other interlocutors comment insightfully on Larsen's chapters and open up further seams of interpretation.

HANSEN LECTURESHIP SERIES

GEORGE MACDONALD IN THE AGE OF MIRACLES

INCARNATION DOUBT, AND REENCHANTMENT

TIMOTHY LARSEN

IVP Academic

An imprint of InterVarsity Press
Downers Grove, Illinois

InterVarsity Press
P.O. Box 1400, Downers Grove, IL 60515-1426
ivpress.com
email@ivpress.com

InterVarsity Press® is the book-publishing division of InterVarsity Christian Fellowship/USA®, a movement of students and faculty active on campus at hundreds of universities, colleges, and schools of nursing in the United States of America, and a member movement of the International Fellowship of Evangelical Students. For information about local and regional activities, visit intervarsity.org.

All Scripture quotations, unless otherwise indicated, are taken from the King James Version. Public domain.

Excerpt from "Burnt Norton" from Four Quartets *by T. S. Eliot. Copyright © 1936 by Houghton Mifflin Harcourt Publishing Company, renewed 1964 by T. S. Eliot. Reprinted by permission of Houghton Mifflin Harcourt Publishing Company. All rights reserved.*

Excerpt from Four Quartets *by T. S. Eliot are also reprinted by permission of Faber and Faber Ltd.*

The poem "Pain and Sorrow" by George MacDonald appears in George MacDonald: Victorian Mythmaker *by Rolland Hein (Nashville: Star Song, 1993), 317, and is used by permission of Wipf and Stock Publishers. www.wipfandstock.com*

Cover design: David Fassett
Interior design: Jeanna Wiggins
Images: George Macdonald drawing: George MacDonald / Private Collection / © Look and Learn /
 Illustrated Papers Collection / Bridgeman Images
 fire illustration: © Homunkulus28 / iStock / Getty Images Plus
 flower illustration: © nicoolay / E+ / Getty Images
 grunge paper background: © billnoll / iStockphoto

ISBN 978-0-8308-5373-1 (print)
ISBN 978-0-8308-7404-0 (digital)

Printed in the United States of America ∞

InterVarsity Press is committed to ecological stewardship and to the conservation of natural resources in all our operations. This book was printed using sustainably sourced paper.

Library of Congress Cataloging-in-Publication Data
A catalog record for this book is available from the Library of Congress.

P 25 24 23 22 21 20 19 18 17 16 15 14 13 12 11 10 9 8 7 6 5 4 3 2 1

Y 37 36 35 34 33 32 31 30 29 28 27 26 25 24 23 22 21 20 19 18

FOR THE

WHEATON
COLLEGE
COMMUNITY

PAST, PRESENT,
AND FUTURE

With Gratitude

CONTENTS

INTRODUCTION to the
Hansen Lectureship Series–1
Walter Hansen

1 George MacDonald in
the Age of the Incarnation–11
Response: James Edward Beitler III

2 George MacDonald
and the Crisis of Doubt–49
Response: Richard Hughes Gibson

3 George MacDonald and the
Reenchantment of the World–95
Response: Jill Peláez Baumgaertner

CONTRIBUTORS–137

AUTHOR INDEX–139

SUBJECT INDEX–141

SCRIPTURE INDEX–143

INTRODUCTION TO THE HANSEN LECTURESHIP SERIES

WALTER HANSEN

THE KEN AND JEAN HANSEN LECTURESHIP

I was motivated to set up a lectureship in honor of my parents, Ken and Jean Hansen, at the Wade Center primarily because they loved Marion E. Wade. My father began working for Mr. Wade in 1946, the year I was born. He launched my father and mentored him in his business career. Often when I look at the picture of Marion Wade in the Wade Center, I give thanks to God for his beneficial influence in my family and in my life.

After Darlene and I were married in December 1967, the middle of my senior year at Wheaton College, we invited Marion and Lil Wade for dinner in our apartment. I wanted Darlene to get to know the best storyteller I've ever heard.

When Marion Wade passed through death into the Lord's presence on November 28, 1973, his last words to my father were, "Remember Joshua, Ken." As Joshua was the one who followed

Moses to lead God's people, my father was the one who followed Marion Wade to lead the ServiceMaster Company.

After members of Marion Wade's family and friends at Service-Master set up a memorial fund in honor of Marion Wade at Wheaton College, my parents initiated the renaming of Clyde Kilby's collection of papers and books from the seven British authors—C. S. Lewis, J. R. R. Tolkien, Dorothy L. Sayers, George MacDonald, G. K. Chesterton, Charles Williams, and Owen Barfield—as the Marion E. Wade Collection.

I'm also motivated to name this lectureship after my parents because they loved the literature of these seven authors whose papers are now collected at the Wade Center.

While I was still in college, my father and mother took an evening course on Lewis and Tolkien with Dr. Kilby. The class was limited to nine students so that they could meet in Dr. Kilby's living room. Dr. Kilby's wife, Martha, served tea and cookies.

My parents were avid readers, collectors, and promoters of the books of the seven Wade authors, even hosting a book club in their living room led by Dr. Kilby. When they moved to Santa Barbara in 1977, they named their home Rivendell, after the beautiful house of the elf Lord Elrond, whose home served as a welcome haven to weary travelers as well as a cultural center for Middle-earth history and lore. Family and friends who stayed in their home know that their home fulfilled Tolkien's description of Rivendell:

> And so at last they all came to the Last Homely House, and found its doors flung wide. . . . [The] house was perfect whether

you liked food, or sleep, or work, or story-telling, or singing, or just sitting and thinking best, or a pleasant mixture of them all.... Their clothes were mended as well as their bruises, their tempers and their hopes.... Their plans were improved with the best advice.[1]

Our family treasures many memories of our times at Rivendell, highlighted by storytelling. Our conversations often drew from images of the stories of Lewis, Tolkien, and the other authors. We had our own code language: "That was a terrible Bridge of Khazaddûm experience." "That meeting felt like the Council of Elrond."

One cold February, Clyde and Martha Kilby escaped the deep freeze of Wheaton to thaw out and recover for two weeks at my parents' Rivendell home in Santa Barbara. As a thank-you note, Clyde Kilby dedicated his book *Images of Salvation in the Fiction of C. S. Lewis* to my parents. When my parents set up our family foundation in 1985, they named the foundation Rivendell Stewards' Trust. In many ways, they lived in and they lived out the stories of the seven authors. It seems fitting and proper, therefore, to name this lectureship in honor of Ken and Jean Hansen.

ESCAPE FOR PRISONERS

The purpose of the Hansen Lectureship is to provide a way of escape for prisoners. J. R. R. Tolkien writes about the positive role of escape in literature:

I have claimed that Escape is one of the main functions of fairy-stories, and since I do not disapprove of them, it is plain that I

[1]J. R. R. Tolkien, *The Hobbit* (London: Unwin Hyman, 1987), 50-51.

do not accept the tone of scorn or pity with which "Escape" is now so often used: a tone for which the uses of the word outside literary criticism give no warrant at all. In what the misusers of Escape are fond of calling Real Life, Escape is evidently as a rule very practical, and may even be heroic.[2]

Note that Tolkien is not talking about *escapism* or an avoidance of reality, but rather the idea of escape as a means of providing a new view of reality, the true transcendent reality that is often screened from our view in this fallen world. He adds:

Evidently we are faced by a misuse of words, and also by a confusion of thought. Why should a man be scorned, if, finding himself in prison, he tries to get out and go home? Or if, when he cannot do so, he thinks and talks about other topics than jailers and prison-walls? The world outside has not become less real because the prisoner cannot see it. In using Escape in this [derogatory] way the [literary] critics have chosen the wrong word, and, what is more, they are confusing, not always by sincere error, the Escape of the Prisoner with the Flight of the Deserter.[3]

I am not proposing that these lectures give us a way to escape from our responsibilities or ignore the needs of the world around us, but rather that we explore the stories of the seven authors to escape from a distorted view of reality, from a sense of hopelessness, and to awaken us to the true hope of what God desires for us and promises to do for us.

[2]J. R. R. Tolkien, "On Fairy-Stories," in *Tales from the Perilous Realm* (Boston: Houghton Mifflin, 2008), 375.
[3]Tolkien, "On Fairy-Stories," 376.

C. S. Lewis offers a similar vision for the possibility that such literature could open our eyes to a new reality:

> We want to escape the illusions of perspective. . . . We want to see with other eyes, to imagine with other imaginations, to feel with other hearts, as well as with our own. . . . The man who is contented to be only himself, and therefore less a self, is in prison. My own eyes are not enough for me, I will see through those of others. . . . In reading great literature I become a thousand men yet remain myself. . . . Here as in worship, in love, in moral action, and in knowing, I transcend myself; and am never more myself than when I do.[4]

The purpose of the Hansen Lectureship is to explore the great literature of the seven Wade authors so that we can escape from the prison of our self-centeredness and narrow, parochial perspective in order to see with other eyes, feel with other hearts, and be equipped for practical deeds in real life. As a result, we will learn new ways to experience and extend the fulfillment of our Lord's mission: "to proclaim freedom for the prisoners and recovery of sight for the blind, to set the oppressed free" (Lk 4:18 NIV).

PENTECOSTAL FIRE

Timothy Larsen's following three lectures on George MacDonald lead us in a chronological-logical sequence from joyfully celebrating the birth of the Messiah with festivities to faithfully following Jesus with fellow doubters to humbly receiving the purifying

[4]C. S. Lewis, *An Experiment in Criticism* (Cambridge: Cambridge University Press, 1965), 137, 140-41.

Pentecostal fire in the trials of life. I am especially enchanted by seeing the way that MacDonald's myth of the mystical fire of roses is an image of his own experience of the refining fire of the Spirit. When Dr. Larsen reflects on the meaning of the rosefire at the end of his last lecture, he quotes the last lines of T. S. Eliot's *Four Quartets*, which itself quotes Julian of Norwich:

And all shall be well and
All manner of things shall be well
When the tongues of flame are in-folded
Into the crowned knot of fire
And the fire and the rose are one.[5]

Larsen's quote points to an illuminating link between MacDonald and Eliot. We gain more understanding of the rosefire in MacDonald's mythology and personal experience by looking at the image of Pentecostal fire in Eliot's *Four Quartets*. A few lines before Larsen's quote from Eliot, we read these lines:

The dove descending breaks the air
With flame of incandescent terror
Of which the tongues declare
The one discharge from sin and error.
The only hope, or else despair
Lies in the choice of pyre or pyre—
To be redeemed from fire by fire.
Who then devised the torment? Love.
Love is the unfamiliar Name
Behind the hands that wove

[5]T. S. Eliot, "Little Gidding," in *Four Quartets*, V, lines 255-59.

The intolerable shirt of flame

Which human power cannot remove.

We only live, only suspire

Consumed by either fire or fire.[6]

Eliot wrote "Little Gidding" as the fourth poem of the *Four Quartets* between 1940 and 1942 while he served as a fire warden during the Blitz in London. This war poem describes his traumatic experience. Fulfilling his duty, he walked through ruins and rubble in the early morning to report fires and destruction caused by wave after wave of German bombers during the "interminable night."[7] Eliot's image of the "dark dove with flickering tongue" uses the name of Germany's first military plane, the Taube, or Dove.[8] Later in this poem, his reference to the dove sounds at first like another description of German terror bombing:

The dove descending breaks the air

With flame of incandescent terror

But the next lines point in a totally different direction:

Of which the tongues declare

The one discharge from sin and error.

The beginning of "Little Gidding" informs us that "pentecostal fire" is a theme of this poem.[9] The "exasperated spirit" is "restored by that refining fire."[10] In continuity with that theme, the "dove

[6]"Little Gidding," IV, lines 200-213.
[7]"Little Gidding," II, lines 79.
[8]"Little Gidding," II, line 81.
[9]"Little Gidding," I, line 10.
[10]"Little Gidding," III, lines 144-145.

descending" with tongues of flame refers to the Day of Pentecost when tongues of fire came upon the apostles (Acts 2:1-4). Filled with the Holy Spirit, they began speaking with other tongues to declare forgiveness of sins through Jesus Christ (Acts 2:38).

This double entendre sounds sacrilegious. Is the dove descending both the German fire bomber and the Holy Spirit? Yes. Both bring fire and death, but completely different kinds of fire and death. That's the point of this layering of meanings. Both the dove-bombers and the Dove-Holy Spirit brought fire and a sudden end to the normal routines of life. The fire of the bombers is the destructive fire of pride, greed, and hate. The fire of the Holy Spirit is the redemptive fire of divine love.

Eliot presents us with a choice:

The only hope, or else despair
Lies in the choice of pyre or pyre—
To be redeemed from fire by fire.

To choose to fight the fire of hate with the fire of hate is the way of despair. Our only hope is to choose the fire of God's love: "to be redeemed from fire by fire." Martin Luther King Jr. set forth this choice: "Returning hate for hate multiplies hate, adding deeper darkness to a night already devoid of stars. Darkness cannot drive out darkness; only light can do that. Hate cannot drive out hate; only love can do that."[11]

"Love" devised this redemptive fire: "Love is the unfamiliar Name." Such an oblique reference to God keeps the language in the realm of modern poetry. To say directly "Love is the name of

[11]Martin Luther King, Jr., *Strength to Love* (Minneapolis: Fortress Press, 2010), 47.

God; God is Love" moves from poetry to prosaic theology. Eliot does not make that move. Rather, he layers and complicates his poetic language even more in the next lines with an image from an obscure Greek myth.

Love is the unfamiliar Name
Behind the hands that wove
The intolerable shirt of flame
Which human power cannot remove.

In Greek mythology, the centaur Nessus was killed by Hercules. As he was dying, he gave Dejanira, Hercules's wife, a tunic for her husband, saying that it would keep her husband from unfaithful passions. When Hercules put it on he felt the poison of it become like fire in his bones. He attempted to pull it off but could not. Hate wove the shirt that killed him. In Eliot's poem, love wove the shirt of flame. Love burns away unfaithful passions.

We have to make a choice: the fire of hate that destroys the soul or the fire of love that purifies the soul. Regardless, we will be "consumed by either fire or fire." Dr. Larsen's lectures lead us to see the purifying power of the rosefire in and through George MacDonald's life. MacDonald wisely guides our choice in prayer: "As for us, now will we come to thee, our Consuming Fire. And thou wilt not burn us more than we can bear. But thou wilt burn us. And although thou seem to slay us, yet will we trust in thee."[12]

[12]George MacDonald, *Unspoken Sermons: Series I, II, and III* (Whitethorn, CA: Johannesen, 2004 [orig. 1867, 1885, and 1889]), 24.

GEORGE MACDONALD IN THE AGE OF THE INCARNATION

G EORGE MACDONALD'S second realist novel, *Adela Cathcart* (1864) begins with a chapter titled "Christmas Eve," and the rest of the action unfolds during the twelve days of Christmas. A group of neighbors and their holiday guests have formed themselves into a little club to tell one another stories during the festive season. Thus, not unlike the Arabian Nights (to which we shall return), *Adela Cathcart* is a collection of short stories held together by a framing narrative.

One of these stories is "My Uncle Peter." The eponymous hero, Peter Belper, was born on December 25. He delights in playing Secret Santa, spying out people who are in distress and leaving them anonymous packages of much-needed aid. The nephew narrator recalls, "'Ah, my dear,' he would say to my mother when she

expostulated with him on making some present far beyond the small means he at that time possessed, 'ah, my dear, you see I was born on Christmas day.'"[1]

Moreover, Uncle Peter's jolly, generous soul is continually overflowing in sacrificial acts of kindness all the year round. Much of the action revolves around his giving a home to a poor orphan who is being exploited and abused and his endeavoring to find and rescue her when she is abducted by a wicked woman from her past. The story ends with the observation that "Christmas Day makes all the days of the year as sacred as itself."[2] The author of this tale, George MacDonald (1824–1905), was himself born during Advent, and like Uncle Peter—or the reformed Ebenezer Scrooge—he also honored Christmas in his heart and tried to keep it all the year.[3]

THE CROSS AND THE CRADLE

In a tour de force piece of scholarship, the historian Boyd Hilton has identified the first half of the nineteenth century in Britain as the Age of Atonement and the second half as the Age of the Incarnation.[4] The Age of Atonement was a time when the focus was on Christ's work on the cross as a penal substitution and when

[1]George MacDonald, *Adela Cathcart* (London: Sampson Low, Marston and Company, n.d. [orig. 1864]), 189. While I researched and wrote this chapter especially for the Hansen Lectures at the Wade Center, I am very grateful that the George MacDonald Society invited me to give a plenary address at its biennial meeting at Trinity Hall, Cambridge, July 20-22, 2016, and thus gave me an opportunity to try out on an earlier version of this material. I am also grateful for the help of my research assistant David Monahan.

[2]George MacDonald, *Adela Cathcart*, 221.

[3]Charles Dickens, *A Christmas Carol and The Cricket on the Hearth* (Boston: Houghton Mifflin Company, 1893), 109. *A Christmas Carol* was originally published in 1843.

[4]Boyd Hilton, *The Age of Atonement: The Influence of Evangelicalism on Social and Economic Thought, 1795-1865* (Oxford: Clarendon Press, 1988).

related themes loomed large, such as the wrath of God, the justice of God, and eternal punishment. Around 1850, the theological climate changed to one in which the central doctrine was the incarnation and along with it came an emphasis on themes such as the love of God and the fatherhood of God. This change was largely prompted by growing unease with the old doctrinal scheme. For example, theologians began to question whether it could really be considered right and just to allow an innocent person to be punished for the guilty. Once people began to shy away from defending the traditional theory of Christ's work on the cross, they found it difficult to formulate an alternative one and therefore instead welcomed the idea of simply shifting the locus of the proclamation of the gospel to another doctrine, from the cross to the cradle.

Although Hilton brilliantly relates this theological shift to nineteenth-century political, social, and economic attitudes and policies, he was not the first to discern it. In fact, the Victorians themselves were aware of it and commented on it. George Mac-Donald had been ordained a Congregational minister, and one of the greatest Congregational pastors and theologians in nineteenth-century Britain was R. W. Dale (1829–1895). In 1889, Dale gave an address that was then published, *The Old Evangelicalism and the New*. In it, he expounded to his audience on the contrast between the faith of their fathers and their own:

> The difference is due to many causes; and among these, very considerable importance must be attributed to the great place which is now given to the fact of the Incarnation. . . . I do not

mean that the Death of Christ for the sins of men is denied by Modern Evangelicals—if it were denied they would cease to be Evangelicals—but it is practically relegated by many to a secondary position. The Incarnation, with all that it reveals concerning God, man, and the universe, concerning this life and the life to come, stands first; with the early Evangelicals the Death of Christ for human sin stood first.[5]

Dale was a bridge-building theologian who was trying to bind the generations together in mutual respect and appreciation. Others, however, were less careful. Another congregationalist, D. W. Simon, let the manger of Bethlehem thoroughly subsume and eclipse the cross of Calvary in a volume tellingly titled *Reconciliation by Incarnation* (1898).[6]

This new doctrinal emphasis was, if anything, even stronger in the communion that MacDonald made his spiritual home for most of his adult life, the Church of England. One of its most famous theological books of the late Victorian period was *Lux Mundi* (1889), which was edited by Charles Gore (1853–1932) who would emerge as one of the most prominent of Anglican theologians and bishops. "Lux Mundi," of course, means "the light of the world," a theme that is proclaimed in the meditation on the incarnation in the opening chapter of John's Gospel: "That was the true Light, which lighteth every man that cometh into the world" (Jn 1:9). Moreover, *Lux Mundi* had as its subtitle *A Series of Studies on the*

[5]R. W. Dale, *The Old Evangelicalism and the New* (London: Hodder and Stoughton, 1889), 43, 48-49. Another important secondary source on this theological shift is Mark Hopkins, *Nonconformity's Romantic Generation: Evangelical and Liberal Theologies in Victorian England* (Milton Keynes: Paternoster, 2004).

[6]D. W. Simon, *Reconciliation by Incarnation* (Edinburgh: T&T Clark, 1898).

Religion of the Incarnation.[7] In other words, the change was so complete that not only were these theologians and clergymen no longer emphasizing that they were determined to know nothing "save Jesus Christ, and him crucified" (1 Cor 2:2), but now they could even speak of the entirety of Christian faith and doctrine under the heading "the religion of the incarnation."

It was easy and commonplace, however, to think and speak that way in the late Victorian period. Far more interesting are the trend-setters earlier in the century who pioneered this theological shift, often in the face of the spirited opposition from members of the older generation who were deeply committed to their own, particular view of the nature of the atonement as the heart of the Christian message. One such leader was the Anglican theologian Frederick Denison Maurice (1805–1872). It would be difficult even to catalog all of the numerous ways that George MacDonald bound himself in love and devotion to F. D. Maurice. MacDonald was himself an early adopter of the gospel of the incarnation and a pioneering spirit who experienced some opposition from the old guard. MacDonald therefore first became attracted to Maurice through his writings and the attacks he endured because of them, sensing right away that they shared a theological affinity. They soon became friends. One of my favorite moments in their relationship is in 1856 when MacDonald became quite ill, his symptoms including coughing up blood. Maurice visited him at his sickbed and read to him John Ruskin's moving account of the risen Christ revealing himself to

[7]Charles Gore, ed., *Lux Mundi: A Series of Studies in the Religion of the Incarnation* (London: John Murray, 1889).

his disciples while they were fishing in the lake of Galilee.[8] The MacDonalds eventually joined St. Peter's Church, Vere Street, London, and thus Maurice became George MacDonald's pastor as well as his friend. MacDonald even wrote a poem in his honor, "A Thanksgiving for F. D. Maurice," and dedicated a book to him, *The Miracles of Our Lord.*[9] MacDonald also paid homage to Maurice by turning him into a fictional character in one of his novels and organized a testimonial gift and tribute for him on the grounds that Maurice was "a teacher come from God."[10] Perhaps most touchingly of all, Maurice became the godfather to the MacDonalds' eighth child, a son whom they christened Maurice in honor of this pastor-theologian-friend who had come from God. As Great-Great-Grandmother Irene so wisely observes in *The Princess and the Goblin*, "A name is one of those things one can give away and keep all the same. I have a good many such things."[11]

As an undergraduate student, Maurice was a member of the Cambridge Apostles, an exclusive intellectual society. In an illuminating study, the historian David Newsome has argued that

[8]William Raeper, *George MacDonald* (Batavia, IL: Lion, 1987), 135; Mary and Ellen Gibbs, *The Bible References in John Ruskin* (London: George Allen, 1898), 37-38. Wheaton College was privileged to have a leading MacDonald scholar, Dr. Rolland Hein, on its faculty until his retirement. I commend his works to those interested in reading more about MacDonald, including Rolland Hein, *George MacDonald: Victorian Mythmaker* (Nashville, TN: StarSong, 1993).

[9]George MacDonald, *The Poetical Works of George MacDonald*, 2 vols. (London: Chatto & Windus, 1915), I:442-43; George MacDonald, *The Miracles of Our Lord* (New York: George Routledge and Sons, n.d. [orig. 1870]).

[10]George MacDonald to Mrs. A. J. Scott, 3 November 1869, *An Expression of Character: The Letters of George MacDonald*, ed. Glenn Edward Sadler (Grand Rapids: Eerdmans, 1994), 171.

[11]George MacDonald, *The Princess and the Goblin* (New York: A. L. Burt, n.d. [orig. 1872]), 20.

their commitment to Platonic thought led the Apostles of Maurice's day, like early church fathers such as Justin Martyr before them, to focus on the Johannine teaching on the *Logos* and therefore to lay "particular stress on the incarnation and its centrality within the Christian revelation."[12] Maurice's controversial *Theological Essays*, published in 1853, highlighted this emphasis. While traditionalists focused their attacks on his willingness to call into question the necessity of believing in the traditional doctrine of eternal punishment, Maurice forcibly stated his objections to the old view of the atonement, arguing that "these notions are becoming more and more intolerable to thoughtful and earnest men."[13] Writing during Advent 1876, the most distinguished Unitarian theologian of the Victorian era, James Martineau (1805–1900)—observing developments among Trinitarians from the outside—gave Maurice the bulk of the credit for this fundamental theological shift: "He has been the chief cause of a radical and permanent change in the 'orthodox' theology,—viz. a shifting of its centre of gravity from the *Atonement* to the Incarnation."[14]

A lot could be at stake in these doctrinal disputes. The MacDonalds' son Greville passed along a family anecdote regarding an aunt of his: "One of the Misses Powell deferred for many months accepting her lover until he could formulate satisfactorily his views on the Atonement; which at last, and most fortunately for the world, he

[12]David Newsome, *Two Classes of Men: Platonism and English Romantic Thought* (London: John Murray. 1974), 78-79.
[13]Frederick Denison Maurice, *Theological Essays* (London: James Clarke & Co., 1957 [orig. 1853]), 104.
[14]James Martineau to Elizabeth P. Peabody, 9 December 1876, *The Life and Letters of James Martineau* by James Drummond and C. B. Upton, 2 vols. (London: James Nisbet & Co., 1902), II:87. Italics in original.

contrived to do."[15] The difference between the Age of Atonement and the Age of the Incarnation was, however, often a generational divide. Part of the reason why MacDonald's calling as the minister of the Congregational church in Arundel was not successful was because his flock found their twenty-something pastor's theological views too progressive. Tellingly, one of his theology professors from Highbury College, the place where he had trained for the ministry, recommended that MacDonald look instead for a congregation to serve that had a high percentage of "young men" in it.[16] Several years later, when things were still not working out, MacDonald would encourage himself in his calling with these words: "I have to do something for the young people of this country."[17]

This generational divide is often dramatized in MacDonald's novels. In his first realist novel, *David Elginbrod*, the foil is Mrs. Elton. She pronounces authoritatively on what a clergyman must include in his sermons:

> He ought in order that men may believe, to explain the divine plan, by which the demands of divine justice are satisfied, and the punishment due to sin averted from the guilty, and laid upon the innocent; that, by bearing our sins, he might make atonement to the wrath of a justly offended God.[18]

The new spiritual sensibility, by way of contrast, is represented by a boy named Harry:

[15]Greville MacDonald, *George MacDonald and His Wife* (London: George Allen & Unwin, 1924), 98.

[16]George MacDonald to his father, 3 June 1853, *Expression of Character*, 61.

[17]George MacDonald to his father, 29 August 1856, *Expression of Character*, 114.

[18]George MacDonald, *David Elginbrod* (London: Hurst and Blackett, n.d. [orig. 1863]), 165.

They were sitting in silence after the close, when Harry started up suddenly, saying: "I don't want God to love me, if he does not love everybody;" and bursting into tears, hurried out of the room. Mrs. Elton was awfully shocked at his wickedness.[19]

To MacDonald's credit, however, the traditionalists are often presented sympathetically in his novels as people who are not themselves as heartlessly punitive as one might expect given their creed. This approach of insisting that a severe figure nevertheless be thought of with affectionate respect is most thoroughly taken in the portrait of Robert Falconer's grandmother, a formidable woman who is, as it were, the Age of Atonement incarnate. Falconer himself struggles his way to an incarnational theology centered on the revelation that God is Love, resisting his Grannie's understanding of the scheme of salvation: "But, laddie, he cam to saitisfee God's justice by sufferin' the punishment due to oor sins; to turn aside his wrath an' curse."[20] Over the course of several hundred pages we watch as Robert Falconer, on behalf of young people everywhere, rejects the harsh rigidities of the old faith and learns how to formulate the new.

This dynamic is recapitulated in *What's Mine's Mine.* When Ian gives his spiritual testimony, his mother is distressed for the state of his soul by its omissions: "There was nothing in it about the atonement!"[21] In a chapter titled "The Gulf That Divided," the two of them have the great dialogue between the old and the new theology. Ian defiantly protests, in what is, of course, MacDonald's own view, "I do not believe what you mean by the atonement; what God

[19]MacDonald, *David Elginbrod*, 327.
[20]George MacDonald, *Robert Falconer* (London: Hurst and Blackett, n.d. [orig. 1868]), 328.
[21]George MacDonald, *What's Mine's Mine* (London: Kegan Paul, n.d. [orig. 1886]), 105.

means by it, I desire to accept."[22] There is a great gulf that divides here indeed. As the raven observes in *Lilith*, "You and I use the same words with different meanings. We are often unable to tell people what they need to know, because they want to know something else, and would therefore only misunderstand what we said."[23]

Tellingly, after MacDonald has set aside the old theory of the atonement in "The Gulf That Divided" we are led straight away, as it were, into the Age of the Incarnation in the very next chapter which is titled, "The Clan Christmas."

THE ADVENT OF THE CHILD CHRIST

And so we come to the Victorian Christmas. Today when we think of celebrating the birth of Christ, our minds often gravitate to the nineteenth century. The town where I live, Wheaton, Illinois, advertises its holiday events under the general heading "Dickens of a Christmas." We know that many features of yuletide that feel traditional were first introduced to Britons and Americans in the Victorian age, not least Christmas cards and Christmas trees. Less well known, however, is that during the nineteenth century, Christmas became "the most wonderful time of the year." Previously, Easter held its preeminent place as the greatest of Christian festivals. Denominations influenced by the Reformed tradition usually did not observe the birth of Christ at all. MacDonald, of course, was a Scotsman who was taught the Westminster Catechism as a boy and raised in Scottish Calvinism, and the Church of

[22]MacDonald, *What's Mine's Mine*, 111.

[23]George MacDonald, *The Visionary Novels of George MacDonald*, ed. Anne Fremantle (New York: Noonday Press, 1954), 45. *Lilith* was originally published in 1895.

Scotland did not even begin to have Christmas services until as late as 1873.[24] In its early years, Wheaton, the Christian college in Illinois where I teach, so much made a point of disregarding Christmas as to include it in the Fall semester. In 1864, for instance, the final examinations for the term were held on December 26.[25]

I am positing that this theological shift to the centrality of the doctrine of the incarnation in the Victorian era was a contributing factor in the elevation of Christmas as the supreme holiday in that same time period. F. D. Maurice's first collection of sermons was suggestively titled *Christmas Day and Other Sermons*. In it, he refers to the celebration of the Nativity as "the great Christian Festival." (Note the definite article; he did not even prudentially say "a" great Christian festival so as to leave a place for Easter to at least be on an equal plane.)[26] In his book-length dramatic poem, *Within and Without*, MacDonald referred to December 25 as "this one day that blesses all the year."[27] Likewise, Grenville MacDonald learned from his parents that Christmas is "the Day of Days."[28] The celebration of Christ's birth looms large throughout his biography

[24]Duncan Forrester and Douglas Murray, eds., *Studies in the History of Worship in Scotland* (Edinburgh: T&T Clark, 1984), 91.

[25]Ann Ferguson to Mary Blanchard, 26 December 1864, Wheaton College Archives, Wheaton, IL. I am grateful to Dr. David Maas, Professor of History emeritus, for providing me with this reference.

[26]Frederick Denison Maurice, *Christmas Day and Other Sermons* (London: Macmillan and Co., 1892 [orig. 1843]), vii.

[27]George MacDonald, *Within and Without* (New York: Scribner, Armstrong & Co., 1872 [orig. 1855]), 125. I first presented the material in this paper at a conference of the George MacDonald Society, Trinity Hall, Cambridge, 22 July 2016. Dr. Daniel Gabelman was there, and he pointed me to his own article on this theme, with special reference to *Within and Without*: Daniel Gabelman, "'The Day of All the Year': MacDonald's Christmas Aesthetic," *North Wind* 29 (2010): 11-23.

[28]Greville MacDonald, *George MacDonald and His Wife*, 284.

of his parents, even warranting an entire chapter on this theme, which is titled "Adeste Fideles."[29] While this has become so much to be expected for us that we would not find it much worth commenting upon, it was clearly viewed as a novelty at the time that the MacDonald family prioritized gathering together every year for the Christmas season. And their enthusiastic celebrations were often commented upon by outsiders. Georgina Mount-Temple, for example, reported this on Christmas Eve 1883 at Bordighera, Italy, where the MacDonalds had come to live, and where she had rented a villa and was staying to recuperate after a bad fall:

> On Christmas Eve, we were dining in our little room looking on the olive wood, and we heard the sound of many voices, and looking out, lamps glimmered among the trees, and figures carrying lanterns and sheets of music. Who should they be but the dear MacDonald family visiting the houses of all the invalids in the place, to sing them carols and bring them the glad tidings of Christmas. The next day they had beautiful tableaux of the Annunciation, the Stable, the Angels, and the Shepherds, ending up with the San Sisto [i.e., the Madonna and Child], in their wonderful room in the Coraggio [the MacDonald's house], and they had invited the peasants to come and join this, for them novel representation of the events of the blessed Christmastide.[30]

In MacDonald's realist novels there is often a Christmas chapter or scene (and there is even one in his long poem *Within and Without*). In *Annals of a Quiet Neigbourhood*, the narrator is a

[29]Greville MacDonald, *George MacDonald and His Wife*, 285-89.
[30]Raeper, *George MacDonald*, 354.

clergyman and he explicitly states that his goal is to increase the importance of Christmas in his congregation.[31] He prepares a sheet of Christmas hymns and carols that contain the true meat of God's Word in them, to distribute to his parishioners, and MacDonald cunningly reproduces it *in toto* in the novel as a kind of appendix to the chapter so that his readers are also surreptitiously provided with a full kit for celebrating the birth of our Lord in all of its spiritual richness.[32] MacDonald's *Diary of an Old Soul* is a book that offers a poem for every day of the year. In it, not only does he ignore the possible significance of any other date in the year, but the entry for December 25 even makes it explicit that he is violating this deliberate policy because Christmas is the single occasion in our annual calendar that cannot be ignored:

> Thou hast not made, or taught me, Lord to care
> For times and seasons—but this one glad day
> Is the blue sapphire clasping all the lights
> That flash in the girdle of the year so fair
> When thou wast born a man—because always
> Thou wast and art a man through all the flights
> Of thought and time, and thousandfold creation's play.[33]

Which leads us on to MacDonald's poetry. In *The Poetical Works of George MacDonald* there is not a single poem which has any

[31]George MacDonald, *Annals of a Quiet Neighbourhood* (New York: George Routledge and Sons, 1869 [orig. 1867]), 169.

[32]MacDonald, *Annals*, 184-89.

[33]George MacDonald, *The Diary of an Old Soul* (London: George Allen & Uwin, 1922 [orig. 1880]), 167.

of the following words (or any such related terms) in its title: Good Friday, Easter, Holy Week, Holy Saturday, atonement, crucifixion, the cross, ransom, blood, sacrifice, substitution, justification, propitiation, Golgotha, or Calvary. The closest is "The Burnt-Offering," a poem about making one's life a daily sacrifice unto God.[34] On the other hand, there are no fewer than fourteen poems that have the word "Christmas" in their very title, and numerous others beside these which are also Christmas poems. (In another illustration of my point, when Robert Browning published *Christmas-Eve and Easter-Day: A Poem*, MacDonald wrote a review that completely ignored the Easter half and instead discussed exclusively Christmas Eve.)[35] In his *Unspoken Sermons*, as he had explicitly set aside penal substitution, MacDonald imagines readers asking him what, then, his own theory of the work of Christ on the cross is, to which he defiantly replies, "I answer, *None*."[36] Again, an apophatic approach to a doctrine is likely to make one rather taciturn on the subject matter. From clues from his letters, by contrast, it is clear that MacDonald was in the habit of writing a Christmas poem annually as part of his own, personal celebration of the holiday. In fact, a handful of poems in the published collection simply have the date for their title: "Christmas-Day, 1878," "Christmas, 1880," and so on. Moreover, to MacDonald's great credit, his yule poems are about the Good News of the

[34]George MacDonald, *Poetical Works*, I:251.

[35]George MacDonald, "Browning's 'Christmas Eve,'" in *A Dish of Orts: Chiefly Papers on the Imagination and Shakespeare* (London: Edwin Dalton, 1908), 195-217. This review essay by MacDonald was originally published in 1853.

[36]George MacDonald, *Unspoken Sermons: Series I, II, and III* (Whitethorn, CA: 2004 [orig. 1867, 1885, and 1889]), 532.

coming of God as a human being into the world rather than focusing on the cultural aspects of the season. "Christmas, 1884" even goes so far as to set the one against the other:

Though in my heart no Christmas glee,
Though my song-bird be dumb,
Jesus, it is enough for me
That thou are come.[37]

One of my favorites is "The Sleepless Jesus." It is so much better than the Victorian carol, "Away in the Manger," with its Docetic-tinged "no crying he makes." In MacDonald's vision, Jesus is a real, human baby who—to the frustration of his worn-out mother—is not cooperating with the bedtime ritual. Here is the opening stanza:

'Tis time to sleep, my little boy:
Why gaze thy bright eyes so?
At night our children, for new joy
Home to thy father go,
But thou are wakeful! Sleep, my child;
The moon and stars are gone;
The wind is up and raving wild,
But thou are smiling on![38]

The American Civil War led to great distress and deprivation for the laboring classes in the North of England as so much of the economy of the region was based on textile mills which used as their raw material cotton supplied by the Southern states.

[37]MacDonald, *Poetical Works*, I:302.
[38]MacDonald, *Poetical Works*, I:300-1.

Moreover, these workers had heroically agreed—to their own, personal ruin—that the need to stand against the evil of slavery meant that boycotting the Confederacy was the right policy to pursue. Here is the first stanza of MacDonald's "A Christmas Carol for 1862, The Year of the Trouble in Lancashire":

The skies are pale, the trees are stiff,
The earth is dull and old;
The frost is glittering as if
The very sun were cold.
And hunger fell is joined with frost,
To make men thin and wan:
Come, babe, from heaven, or we are lost;
Be born, O child of man.[39]

When he sent his annual Christmas poem to a friend in December 1886, MacDonald remarked on its theme, the Nativity, "If the story were not true, nothing else would be worth being true. Because it is true, everything is lovely-precious."[40]

MacDonald also wrote Christmas-themed short stories. The most poignant of these is "The Gifts of the Child Christ."[41] Mrs. Greatorex is a twenty-something wife who has a little girl they call Phosy and who is pregnant with their second child. Her husband, alas, has been becoming more and more skeptical and dismissive of spiritual realities as he is correspondingly becoming

[39]MacDonald, *Poetical Works*, I:298-99.
[40]George MacDonald to Georgina Cowper-Temple, 20 December 1886, *Expression of Character*, 321.
[41]George MacDonald, *The Gifts of the Child Christ, Fairytales and Stories for the Childlike*, ed. Glenn Edward Sadler, 2 vols. (London: A. R. Mowbray & Co., 1973 [orig. 1882]). "The Gifts of the Child Christ" is in I:31-60.

more materialistic. In an ominous sign regarding the state of his eternal soul, we are told that "he had given up reading poetry."[42] Mr. Greatorex's heart is also becoming more and more emotionally detached from his wife and—anxious and not knowing what to do—she senses that she is losing him. Meanwhile, Phosy, being but a child, has the import of Advent all jumbled up:

> From some of his [the preacher's] sayings about the birth of Jesus into the world, into the family, into the individual human bosom, she had got it into her head that Christmas Day was not a birthday like that she had herself last year, but that, in some wonderful way, to her requiring no explanation, the baby Jesus was born every Christmas afresh.[43]

Mrs. Greatorex goes into labor during the night before Christmas, but the baby is stillborn. The infant's dead body is placed in the spare room, where Phosy, rising early on Christmas morn as children are wont to do, discovers it all by herself, not knowing the tragic event that had unfolded while she lay sleeping. Eventually she is found by the rest of the household. "'Jesus is dead,' she said, slowly and sadly, but with perfect calmness. 'He is dead,' she repeated. 'He came too early, and there was no one up to take care of him, and he's dead—dead—dead!'"

This ghastly scene jolts her father back into spiritual vitality. Rising to the moment, he makes a true confession: "'No, no, Phosy!' they heard him say, 'Jesus is not dead, thank God. It is only your little brother that hadn't life enough, and is gone back to God for

[42]MacDonald, *Gifts of the Child Christ*, I:46.
[43]MacDonald, *Gifts of the Child Christ*, I:47.

more.'" Faith and family are both renewed: "Such were the gifts the Christ-child brought to one household that Christmas."[44]

The more substantive point, however, is not that MacDonald wrote about Christmas but that he is a fine representative of the Age of the Incarnation in terms of the theological themes that he stressed throughout his life, work, sermons, and ministry. Central to his message was the Fatherhood of God. God's great father-heart reveals that he is fundamentally a God of love and that this inexhaustible divine love is directed specifically towards us, his children. "Papa's Story (a Scot's Christmas Story)" is a modern retelling of the parables of the lost sheep and of the prodigal son, biblical passages that MacDonald would return to again and again because they reveal that God is a loving Father.[45] In the incarnation, the Son came to earth to make known to us his Father in heaven. During his earthly life, Jesus of Nazareth modeled for us how to be a true, obedient child of the Father. One of MacDonald's favorite Christological titles, therefore, was to refer to Jesus as our Elder Brother.[46]

YULETIDE SPIRITS

What it means to be a disciple of Jesus Christ is to be born again and to become like a child. The very first chapter in MacDonald's *Unspoken Sermons* is "The Child in the Midst," a meditation on

[44]MacDonald, *Gifts of the Child Christ*, I:60.

[45]MacDonald, *Gifts of the Child Christ*, I:309-33. "Papa's Story [A Scot's Christmas Story]" was originally published in 1865.

[46]For example, in one poem, Christ is addressed as "Great elder brother of my second birth" in MacDonald, *Diary of an Old Soul*, 81. See also George MacDonald, *Thomas Wingfold, Curate* (New York: George Routledge and Sons, n.d. [orig. 1876]), 605; MacDonald, *Miracles*, 41.

God's call for us to become childlike.[47] "Suffer little children, and forbid them not, to come unto me: for of such is the kingdom of heaven" (Mt 19:14). In *At the Back of the North Wind*, Diamond is made fun of for being simple-minded, for having "a tile loose." He is referred to derisively as "God's baby." But this just shows how little spiritual discernment some people have, for "of God's gifts a baby is of the greatest."[48] To live the Christian life is to have the incarnation become a reality in our hearts: "We must become as little children, and Christ must be born in us."[49] We therefore need a little Christmas, right this very minute.

> It is as if God spoke to each of us according to our need, "My son, my daughter, you are growing old and cunning; you must grow a child again, with my Son, this blessed birth-time. You are growing old and selfish; you must become a child. You are growing old and careful; you must become a child. You are growing old and distrustful; you must become a child. You are growing old and petty, and weak, and foolish; you must become a child—my child, like the baby there, that strong sunrise of faith and hope and love, lying in his mother's arms in the stable.[50]

Our true spiritual destiny therefore is not to grow old, but to grow young. At the end of their adventure in "The Golden Key," Tangle and Mossy are not only better, stronger, and wiser, but even *younger*

[47]MacDonald, "The Child in the Midst," in *Unspoken Sermons*, 1-17.
[48]George MacDonald, *At the Back of the North Wind* (London: J. M. Dent & Sons, 1959 [orig. 1871]), 250, 266.
[49]MacDonald, *Unspoken Sermons*, 363.
[50]MacDonald, *Adela Cathcart*, 20-21.

"than they had ever been before."[51] In *Lilith*, we hear these words of eschatological hope for our ultimate sanctification: "Sooner or later all will be little ones."[52] To celebrate her fifty-sixth birthday, MacDonald composed these lines for his friend Georgina Cowper-Temple:

Up the hill of years,
To the peak of youth!
There the mist of fears
Veils no more the truth;
There we children all shall meet,
And play about the Father's feet.[53]

MacDonald's poem "Christmas Song of the Old Children" is addressed to Jesus, who is given the Christological title "Child of all Eternity!" and it includes these lines: "Childhood all from thee doth flow—/ Melt to song our age's snow."[54]

And MacDonald practiced what he preached. G. K. Chesterton dubbed him "St. Francis of Aberdeen," and I think part of what makes that startling comparison apt is the childlike quality in both the Protestant author from Aberdeen and the medieval saint from Assisi.[55] George MacDonald was an old soul whose deep wisdom was that God wants us to learn how to be a child again. Delightfully conforming

[51]MacDonald, "The Golden Key," in *Gifts of the Child Christ*, I:191. This was originally published in 1867.

[52]MacDonald, *Visionary Novels*, 219.

[53]George MacDonald to Georgina Cowper-Temple, 7 October 1877, *Expression of Character*, 257.

[54]MacDonald, *Poetical Works*, I:306-07.

[55]G. K. Chesterton, "Introduction," in Greville MacDonald, *George MacDonald and His Wife*, 14. For a study that pays attention to this aspect of MacDonald's life and thought, see Daniel Gabelman, *George MacDonald: Divine Carelessness and Fairytale Levity* (Waco, TX: Baylor University Press, 2013).

to our mental picture of what a Victorian boy might receive for a Christmas present, MacDonald even had a collection of toy soldiers which he added to and played with throughout his adult life.[56] As the narrator reflects in *David Elginbrod*, "I do not think that any man is compelled to bid good-bye to his childhood."[57] Moreover, Christmas does not just remind us that God himself once became a baby in Jesus Christ, but rather it reveals to us a deep, abiding truth about the very nature of the Almighty. As MacDonald expounded in one of his *Unspoken Sermons*, "God is child-like. . . . Let me then ask, do you believe in the Incarnation? . . . Our Lord became flesh. . . . And he was, is, and ever shall be divinely childlike. . . . Childhood belongs to the divine nature."[58] In *Within and Without* we are told that the Nativity "brought godlike childhood to the aged earth."[59]

Thus the Victorians have also taught us that children should be at the heart of our Christmas celebrations. This too seems so obvious as to be self-evident to us, but it was not always so. The medieval Christmas was, in spirit, much more like how we think of New Year's Eve: a time for adult revelry, including gambling. Even the gift-giving was about reinforcing formal relationships between adults within a hierarchical, social world.[60] The Age of the Incarnation insisted that yuletide festivities should be geared towards children and domestic life. One popular tradition was

[56]Raeper, *George MacDonald*, 168. For MacDonald's playfulness, see Gabelman, *George MacDonald*.

[57]MacDonald, *David Elginbrod*, 32.

[58]George MacDonald, *Unspoken Sermons*, 12-13.

[59]MacDonald, *Within and Without*, 126.

[60]For a history of the festival across the centuries, see Gerry Bowler, *Christmas in the Crosshairs: Two Thousand Years of Denouncing and Defending the World's Most Celebrated Holiday* (New York: Oxford University Press, 2016).

reading stories aloud by the fireside. This is a point, however, at which we realize that we have also diverged in some ways from nineteenth-century customs. If the medieval Christmas was more akin to New Year's Eve, so the Victorian Christmas had affinities with our Halloween. In particular, the Christmas season was a traditional time to tell ghost stories. We still have a trace of a memory of this in popular culture today, such as the song "It's the Most Wonderful Time of the Year": "There'll be scary ghost stories / And tales of the glories of Christmases long, long ago." And it is easy for us to forget that Dickens's *A Christmas Carol* is actually a ghost story. Moreover, it was just one of a series of ghost stories that Dickens wrote over the years for families to enjoy as part of their celebrations of the birth of Jesus in Bethlehem. Reinforcing yet more strongly the Halloween connection, one of Dickens's Christmas stories was even called "The Haunted House."[61] Moreover, by extension, yuletide was a time for stories about all sorts of creatures—weird and wondrous; sinister, supernatural, and mysterious; mythical, fantastical, and fabulous. I assure you that I have no desire to try to turn Jo March into a proper and conventional lady, but it was not startling when *Little Women* was published in 1869 the way it would be for us now that Jo wrote a play to be performed on Christmas Day titled "The Witches Curse."[62]

And so, as promised, we return to the Arabian Nights, which was one of the MacDonald family's favorite collections of stories

[61]Charles Dickens, *Christmas Stories* (London: Chapman & Hall, n.d.). "The Haunted House" was originally published in 1859.

[62]Louisa M. Alcott, *Little Women and Good Wives* (London: J. Nisbet & Co., n.d. [orig. 1869]). "The Witch's Curse" would be a more accurate way of writing this title. Perhaps Alcott wanted to remind us that they were still children.

for Christmas reading. The character Robert Falconer's own initial encounter with the Arabian Nights was exquisite beyond description: "I shrink from all attempt to set forth in words the rainbow-coloured delight that coruscated in his brain."[63] In the Wade Center collection, there is a copy which is not only inscribed to MacDonald's granddaughter Lilia Mary as a Christmas gift but also includes a slip of paper that says, "A Happy Christmas," and is signed by George MacDonald. I could be wrong, but I read this note not as a seasonal greeting (as in "I wish you a Happy Christmas"), but rather as a shortened version of the phrase "That was a happy Christmas," in other words, as a recorded tribute to a fondly remembered Christmas when they read these stories aloud together as a family, which, indeed we know that they did.[64] In short, for the Victorians, the annual celebration of the birth of our Lord was a perfect time to relish a tale about a magician, a wondrous lamp, and "an enormous and frightful genie."[65]

We have discussed MacDonald's Christmas poems, short stories, and scenes in his novels, but as we bring this chapter to a conclusion, I want to point out that even many of MacDonald's works that were not *about* Christmas were nevertheless *for* Christmas.

[63]MacDonald, *Robert Falconer*, 136.
[64]George MacDonald Collection, The Wade Center Archives, Wheaton College, Wheaton, IL: Andrew Lang, ed., *The Arabian Nights Entertainments* (London: Longmans, Green & Co., 1898). The inscription to Lilia Mary was written for Christmas 1905, which came a few months after George MacDonald's death, but, as it also includes his note and as the book was published seven years earlier, it might have been a cherished family copy that was now being gifted to her.
[65]Andrew Lang, ed., *The Arabian Nights Entertainments* (London: Longmans, Green & Co., 1898), 298. Fascinatingly, in the preface Lang describes these stories with the same language that MacDonald used for *Phantastes* as "fairy tales . . . for grown-up people." Lang, *Arabian Nights*, x.

His first book was a work of translation, *Twelve of the Spiritual Songs of Novalis*, which he had privately printed in 1851 as a Christmas gift for his friends.[66] His first proper book, *Within and Without*, was timed for publication with Christmas very much in mind.[67] And the last story George MacDonald ever wrote, "Far Above Rubies," appeared in *The Sketch* in its Christmas 1898 issue; thus Christmastime was the Alpha and Omega of MacDonald's entire publishing life.[68] And this Advent calendar was also true of innumerable publications in between. Most notably, MacDonald thought of *Phantastes* as "a fairy tale or something of the sort" for the Christmas season.[69]

FAITHFUL FAIRIES

To return to the text with which we began this chapter, Adela's aunt, Mrs. Cathcart, is a foil in the novel:

> "This is Christmas-time, you know, and just the time for story-telling," I added.
>
> "I trust it is a story suitable to the season," said Mrs. Cathcart, smiling.
>
> "Yes, very," I said; "for it is a child's story—a fairy tale, namely; though I confess I think it fitter for grown than for young children."[70]

[66]Raeper, *George MacDonald*, 423.

[67]George MacDonald to his father, 17 October 1853, *Expression of Character*, 67.

[68]Raeper, *George MacDonald*, 389.

[69]George MacDonald to his father, 2 December 1857, *Expression of Character*, 124. As another Victorian example of the connection between yuletide and scary stories of spirits, it is worth noting that the Anglo-Catholic poet Christina Rossetti wrote her 1862 *Goblin Market* "as a Christmas book": Georgina Battiscombe, *Christina Rossetti: A Divided Life* (London: Constable, 1981), 101.

[70]MacDonald, *Adela Cathcart*, 62-63.

Thus, delightfully, this fictitious holiday gathering is treated during the twelve days of Christmas to some of MacDonald's own fairy tales, including "The Light Princess" and "The Giant's Heart."[71] Writing fantasy stories for the Christmas market was, of course, also a business decision for MacDonald, but it was wonderfully in keeping with his childlike nature to find a way to get the fairies to pay his bills.

Moreover, there are surely more profound connections in the subterranean depths of fairyland. Mrs. Cathcart complains that even the clergyman in their party has told a tale at Christmastide that has "nothing Christian in the story." She receives this reply:

"I allow that in words there is nothing Christian," answered Mr. Armstrong; ". . . But I cannot allow that in spirit and scope, it is anything other than Christian, or indeed anything but Christian. It seems to me that the whole might be used as a Christian parable."[72]

William Raeper has observed how often in MacDonald's fantasy writings there recurs the theme of "royalty disguised as peasantry," which, of course, is an extraordinarily apt parable indeed for the doctrine of the incarnation, the King of Kings and Lord of Lords wrapped in swaddling clothes, lying in a manger.[73] Still, we must not travel any further in that direction lest, in a misguided effort to answer her, we end up becoming too much like stuffy, old Mrs.

[71]The reader, however, would need to obtain them elsewhere as their full texts are not provided in this novel. Other MacDonald short stories are presented *in toto*, including "Papa's Story (A Scot's Christmas Story)," under the title "The Lost Lamb."
[72]MacDonald, *Adela Cathcart*, 179.
[73]Raeper, *George MacDonald*, 331.

Cathcart. In marked contrast to Adela's aunt, we are told this of Uncle Peter:

> When he had finished his tea, he turned his chair to the fire, and read—what do you think? Sensible Travels and Discoveries, or Political Economy, or Popular Geology? No: Fairy Tales, as many as he could lay hold of; and when they failed him, Romances or Novels.[74]

No, no, as much as we would like to reassure Mrs. Cathcart that all is well and soundly Christian, we cannot seriously bring ourselves to believe that jolly, old Uncle Peter was reading these fairy tales for their didactic capacity to communicate Chalcedonian Christology. Yet neither do we suspect that his Savior whose birthday he shared was any the less pleased with him for all that. And we can say the same for George MacDonald himself. It is enough that his godly, Christ-loving, childlike soul delighted in fantastical stories of fairies, not least at Christmastime. Why should he not have been allowed to enjoy himself in this way? After all, was he not born during Advent? And did he not live in the Age of the Incarnation?

[74]MacDonald, *Adela Cathcart*, 191.

RESPONSE

JAMES EDWARD BEITLER III

WHEN I READ AN EARLY DRAFT of Timothy Larsen's lecture on "George MacDonald in the Age of the Incarnation," what first caught my attention was the amount of evidence he had marshaled in support of his argument. I was further impressed (and delighted) when Larsen sent me another draft in which he had attempted, as he put it, "to stir more pecans into the MacDonald Christmas fruitcake." My admiration and delight turned to awe when I received the next version. The subject line of the email read, "More Pecans!" Larsen's claims are well supported indeed.

The pecans-as-evidence metaphor is somewhat misleading, however, because Larsen is able to bring together so many different types of evidence, drawn from a variety of texts and contexts. To make the case that MacDonald is "a fine representative of the Age of the Incarnation," Larsen serves us historical evidence (e.g., Boyd Hilton's distinction), biographical evidence (MacDonald's relationship with Maurice, his love for Yuletide ghost stories, and his practice of gifting his works to others), literary evidence (analyses of characters and themes in MacDonald's novels and poems), and theological evidence

(MacDonald's views about Christian maturity and his under-
standing of God as "divinely childlike"). This is holiday fare,
seasoned with many flavors.

It is also an especially *timely* contribution. Of course, all aca-
demics want their scholarship to be *kairotic* in relation to the
conversations in their fields, and Larsen's work is certainly timely
in this respect—but it is timely for other reasons as well. Rhetori-
cians have long maintained that ceremonies, festivals, and seasons
are moments of rhetorical potential, and Larsen's argument proves
this to be right, speaking to us with even more meaning on this
dark evening in Advent than it would at other times of the year.
The argument is relevant to us not only for what it says to us
about MacDonald but also because it resonates with the theological
emphases of the Christmas season we are awaiting, inviting us
to think about the ways that we might tap into the rhetorical
potential of the Christian year, even as we do important work in
our disciplines.

The argument is timely in an interpretative sense as well. Larsen
suggests that to fully understand MacDonald's writings, we need
more than a theological statement about the incarnation; we also
need to know something about the theological currents of an age
and about Victorian Christmas practices—such as the emphasis
on ghost stories, for example. This approach rightly implies that
our interpretative practices must account for the fact that our
theologies and our time-keeping practices are interwoven and
often mutually constitutive of each other. In sum, Larsen's argument
features the Christian year as both rhetoric and hermeneutic,

reminding us of the abundant resources our calendar offers for guiding our efforts as writers and readers.

As I prepared my response, I considered the idea of exploring the writings of another Wade Center author in light of Hilton's comments about the Age of the Incarnation. Given C. S. Lewis's emphasis on the incarnation in his writings as well as his affection for MacDonald, he would have made a particularly good choice. Lewis famously wrote that MacDonald's *Phantastes* "baptized his imagination," and he made MacDonald his guide to the afterlife in *The Great Divorce*. Furthermore, in his piece "The Grand Miracle," Lewis gives the doctrine of the incarnation a central place in the Christian narrative.[1] In that piece, he writes, "The story of the Incarnation is the story of a descent and resurrection."[2] However, as I began drafting my response, I found myself drawn away from Lewis to the very place that Larsen warned us of traveling: "the subterranean depths of fairyland." More specifically, I wondered, do we hear echoes of Larsen's points about the Age of the Incarnation in MacDonald's *Phantastes*? Once the question was raised, it took hold of me, and I found myself pulled into Fairy Land with Anodos.

EMBODIED EXISTENCE IN *PHANTASTES*

Reading *Phantastes* with Larsen's thesis in mind, we are confronted with two apparent difficulties, both related to the development of Anodos's character. For one thing, the climax of the story involves

[1]C. S. Lewis, "The Grand Miracle," in *God in the Dock: Essays on Theology and Ethics*, ed. Walter Hooper (Grand Rapids, MI: Eerdmans, 1970), 82, 85.
[2]Lewis, "Grand Miracle," 82.

a sacrificial death. In an act of selfless love, Anodos dies killing a great and terrible beast.[3] His death prevents his master, a knight, from being misled by the evil creature and ensures that the love between the knight and the Marble Lady (whom Anodos himself once longed for) will endure.[4] Famously praised by Lewis for its portrayal of a "*good* Death," *Phantastes* would seem to have more to say to us about atonement than incarnation.[5] Second, Anodos's death results in a kind of disembodied state.[6] Anodos reports that "the souls of [his] passions . . . rose above their vanishing earthly garments, and disclosed themselves angels of light. But oh, how beautiful beyond the old form! I lay thus for a long time . . . satisfied in still contemplation, and spiritual consciousness.[7]" Anodos, whose name can mean "ascent," eventually ends up floating on a "feathery cloud . . . high above the world."[8] His development as a character would seem to move us in the opposite direction of incarnation, and it is not for nothing that Stephen Prickett calls MacDonald a "temperamental Platonist" in his book *Victorian Fantasy*.[9]

Let me pause at this point to remind you that, though Larsen's argument illuminates a great deal about MacDonald's work, he never claimed that the incarnation makes sense of *everything* that MacDonald wrote. What is more, Larsen has specifically instructed

[3]George MacDonald, *Phantastes: A Faerie Romance* (Grand Rapids, MI: Eerdmans, 2000 [1958]), 179.

[4]MacDonald, *Phantastes*, 177-81.

[5]MacDonald, *Phantastes*, xi.

[6]MacDonald, *Phantastes*, 180-182.

[7]MacDonald, *Phantastes*, 180.

[8]MacDonald, *Phantastes*, 181.

[9]Stephen Prickett, *Victorian Fantasy*, 2nd ed. (Waco, TX: Baylor University Press, 2005), 170.

us to be wary of making too much of his thesis in relation to Fairy Land—and rightly so: as MacDonald himself argues in his essay "The Fantastic Imagination," the meanings of good fairy tales are myriad. "Everyone . . . who feels the story," MacDonald writes, "will read its meaning after his own nature and development: one man will read one meaning in it, another will read another."[10] Given such views, we can be certain that MacDonald's primary aim in writing fairy tales was not, as Larsen put it, for "their didactic capacity to communicate Chalcedonian Christology."

Even so, I think Larsen's argument *does* help us understand *Phantastes*. It is worth noting, first of all, that the book offers us yet another connection between MacDonald and F. D. Maurice: Maurice assisted MacDonald in acquiring a publisher for the book.[11] Presumably, he did not find anything in its pages that offended his theological sensibilities too much. Second, and more importantly, there are many times throughout *Phantastes* when Anodos's "ascent" requires him, in Larsen's words, to "grow young." At one point, Anodos tells us that "it is no use trying to account for things in Fairy Land; and one who travels there soon learns to forget the very idea of doing so, and takes everything as it comes; like a child, who, being in a chronic condition of wonder, is surprised at nothing."[12] Third, whatever else it may be, *Phantastes* is a ghost story. Anodos is bewitched by an evil Ash Tree, tormented by his

[10]George MacDonald, "The Fantastic Imagination," website of The George MacDonald Society, accessed July 6, 2016, www.george-macdonald.com/etexts/fantastic_imagination .html. This work also appeared as the introduction to *The Light Princess and Other Fairy Tales* and was reprinted in *A Dish of Orts*.

[11]Prickett, *Victorian Fantasy*, 159.

[12]MacDonald, *Phantastes*, 24. Later Anodos's encounter with a beech tree leaves him feeling "as if new-born" (32). And in one of the book's most heartbreaking episodes, Anodos

shadow, haunted by troubling memories from his past, and made to pass through "the door of Dismay" and eventually "through [his own] tomb."[13] After his death in Fairy Land, he even envisions *himself* as a kind of ghost, crying, "O pale-faced women, and gloomy-browed men, and forgotten children, how I will wait on you, and minister to you, and, putting my arms about you in the dark, think hope unto your hearts, when you fancy no one is near!"[14]

Which brings us back to Anodos's disembodied consciousness. Though that is where his time in Fairy Land ends, it is not where the book ends. Shortly after imagining that he will "haunt" the disheartened people of the world, he is jolted from Fairy Land, returning to an embodied existence.[15] "With this," Anodos tell us, "a pang and a terrible shudder went through me; a writhing as of death convulsed me; and I became once again conscious of a more *limited,* even a *bodily* and *earthly life.*"[16] Though we might make even more of this passage if the embodied Anodos were not so distressed about his "earthly life" and not so perplexed about how to translate his ghostly compassion into the world of things, the scene offers us a clear echo of the incarnation, demonstrating that the doctrine found its way even into MacDonald's other worlds. Again, we cannot get from Anodos's descent to Chalcedon directly, but we can, I think, point to this passage as a place in which MacDonald drew on his faith to advance his narrative.

travels through a door to his youth and must relive the tragic death of his brother (136-137).

[13]MacDonald, *Phantastes*, 184.

[14]MacDonald, *Phantastes*, 182.

[15]MacDonald, *Phantastes*, 182.

[16]MacDonald, *Phantastes*, 182, emphasis added.

THE TWO NATURES

Actually, one could make the case that Chalcedon permeates *Phantastes* in an even more fundamental way. To understand how, we must take a step back from Anodos's character to consider the book's two primary settings: the "real" world and Fairy Land.[17] Stephen Prickett's comments are helpful here:

> In these books . . . the two worlds appear to coexist perfectly within our own world. Though the transitions [from the "real" world to the fantastical world] are often unexpected, they do not involve magical metamorphoses or mysterious entrances like cupboards or mirrors. All they demand is something that

[17]One scholar who has spent a great deal of time thinking about setting in fantasy literature is Farah Mendlesohn, the coeditor with Edward James of *The Cambridge Companion to Fantasy Literature* (Cambridge: Cambridge University Press, 2012). Mendlesohn has developed a taxonomy for classifying fantasy literature based on four ways that these stories present the more realistic (or primary) world in relation to the more fantastical (or secondary) world; the four categories are portal/portal-quest fantasies (characters go through a door to get from the primary to the secondary world), immersive fantasies (the characters are fully immersed in a secondary world and the "real" world is not part of the story), intrusive/intrusion fantasies (the secondary world encroaches on or invades the primary world), and estranged/liminal fantasies (we as readers do not know if we are dealing with a fantasy or not). Farah Mendlesohn, *Rhetorics of Fantasy* (Middletown, CT: Wesleyan University Press, 2008), xix-xxix, and "Toward a Taxonomy of Fantasy," *Journal of the Fantastic in the Arts* 13.2 (2002): 171, 173-81. While Mendlesohn's schema is useful in relation to many works of fantasy literature, MacDonald's fantasies prove to be difficult to classify. Though Mendlesohn does refer to *Phantastes* and *Lilith* as portal fantasies, neither fits perfectly in that category. Farah Mendlesohn and Edward James, *A Short History of Fantasy* (Faringdon: Libri, 2012), 19; Mendlesohn, *Rhetorics*, 21. In her book *Rhetorics of Fantasy*, she calls *Lilith* "a portal novel written before the conventions of the form were settled." Mendlesohn, *Rhetorics*, 21. (Given that *Lilith* was written much later than *Phantastes*, Mendelsohn could just as easily be talking about *Phantastes* here.) She goes on to note that *Lilith* "repeatedly veers between the Gothic style, as commonly found in the intrusion fantasy or the liminal fantasy, and the detailed creation and description of landscape and people that is more common to the portal fantasy." Mendlesohn, *Rhetorics*, 21. "The otherworld of the portal fantasy," Mendlesohn continues, "relies on the contrast with the frame world, on the world from which we begin the adventure. . . . Instead MacDonald makes the present world strange." Mendlesohn, *Rhetorics*, 21.

approximates very closely to *faith*: that is, not just belief, or even acceptance, but a very positive *moral* quality that involves, among other things, acting on trust.[18]

One of the clearest examples of this point in *Phantastes* occurs when Anodos glimpses a farmhouse on the edge of the forest in which he has been traveling. The farmhouse turns out to be a liminal space between the "real" world and Fairy Land, not only because it borders the forest but also because of the beliefs of the inhabitants. Anodos meets a woman and her daughter (who both believe in Fairy Land) as well as the woman's husband (who does not believe in Fairy Land and, therefore, cannot see it). The woman says that her husband "could spend the whole of Midsummer-eve in the wood and come back with the report that he saw nothing worse than himself."[19] When Anodos asks how far eastward the woods goes, the man replies, "Oh! for miles and miles; I do not know how far. For although I have lived on the borders of it all my life, I have been too busy to make journeys of discovery into it. Nor do I see what I could discover. It is only trees and trees, till one is sick of them."[20] As he talks with different members of the household, Anodos waivers back and forth between belief and disbelief in Fairy Land. Ultimately, though, the influence of the woman and her daughter win out, allowing Anodos to perceive Fairy Land again and compelling him to return to the forest.

Prickett ultimately frames his discussion about faith as the means of transitioning between the "real" world and Fairy Land

[18]Prickett, *Victorian Fantasy*, 164-65.
[19]MacDonald, *Phantastes*, 49.
[20]MacDonald, *Phantastes*, 52.

in terms of MacDonald's Platonism, but his reading leaves us ample room to see echoes of the incarnation—and, more specifically, the two natures of Christ—in MacDonald's primary and secondary worlds.[21] In fact, Prickett himself points us in this direction. He notes that for MacDonald the world we inhabit

> is the meeting place of two very different kinds of reality, neither of which is fully capable of accounting for everyday experience. Materialism is forced to be reductionist with spiritual experiences; mysticism often fails to take account of material forces. . . . There is no easy reconciliation of the two worlds: in human experience they remain, as they appear, polar opposites. Tragedy is a perpetual possibility; as the crucifixion must remind Christians, there is no easy reconciliation.[22]

Though Prickett does not elaborate on this remark, his comment suggests that, though Chalcedonian Christology is not articulated explicitly in *Phantastes,* it is indeed relevant to the work.

God's Embodied Thoughts

Let me conclude my response by taking one more step back, moving from a consideration of MacDonald's fantasy worlds to his own reflections on fantasy. In his essay "The Fantastic Imagination," which I mentioned earlier, MacDonald suggests that the "true fairytale"—that is, the fairy tale that can be called a work of art—generates meanings beyond its author's intentions. He frames his position in response to an imaginary conversation partner

[21]MacDonald, *Phantastes*, 162, 170.
[22]Prickett, *Victorian Fantasy*, 167-68.

who wants to cling to the notion that meaning depends primarily on authorial aims. This second voice asks, "Must [a fairy tale] have meaning?" MacDonald answers this question with the line I quoted earlier: "Everyone . . . who feels the story, will read its meaning after his own nature and development: one man will read one meaning in it, another will read another."[23] Later MacDonald continues, "A genuine work of art must mean many things; the truer its art, the more things it will mean."[24] Here MacDonald presents us with a theory of creativity that sounds like an early version of reader-response theory, but there is a twist. For MacDonald, the source of a work's many meanings is neither its author's intention nor its readers' interpretation but rather the Author of all meaning:

> For in everything that God has made, there is layer upon layer of ascending significance; also he expresses the same thought in higher and higher kinds of that thought: it is God's things, his embodied thoughts, which alone a man has to use, modified and adapted to his own purposes, for the expression of his thoughts; therefore he cannot help his words and figures falling into such combinations in the mind of another as he had himself not foreseen, so many are the thoughts allied to every other thought, so many are the relations involved in every figure, so many the facts hinted in every symbol.[25]

I feel like I am traveling into truly perilous territory now; however, I will venture to say that while we do hear Platonism in

[23]Macdonald, "Fantastic."
[24]Macdonald, "Fantastic."
[25]Macdonald, "Fantastic."

this description of meaning-making, it is indeed "temperamental," accented by MacDonald's Christianity. Humans, MacDonald writes, use "God's things, his *embodied* thoughts," to express ourselves creatively (emphasis added). I hear echoes of the incarnation here, and I am more convinced that they are present after listening to Larsen's talk. I also have *time* on my side. After all, is it not now Advent? And do we not find ourselves longing, once again, to celebrate the birth of our Lord?

2

GEORGE MACDONALD AND THE CRISIS OF DOUBT

I N GEORGE MACDONALD'S realist novel, *Thomas Wingfold, Curate*, the title character is the clergyman-in-charge of the fictitious parish of Glaston. His religious vocation notwithstanding, Wingfold is so ensconced in the cozy Christendom of the established Church in England that he has never even considered the question of the intellectual credibility of the Christian faith. The curate had entered the ministry simply because he had been advised it would be a secure and congenial way to make a living. His intellectual inattentiveness has been aided by the fact that he has been delivering sermons written by a deceased uncle rather than composing any of his own. Then Wingfold ends up at a dinner party with George Bascombe—"a forward, overbearing young infidel of a lawyer"—who has taken

it upon himself to be an apostle of unbelief.[1] Bascombe openly scoffs at the claim that Christ rose from the dead: "These Christian people, who profess to believe that their great man has conquered death, and all that rubbish."[2] The young skeptic challenges the callow clergyman on the veracity of the entirety of the Church's teaching: "Tell me honestly—do you believe one word of all that?"[3] This blunt question plunges the Reverend Thomas Wingfold into a crisis of faith.

THE DRAMA OF FAITH

The Victorian period has been referred to as the "Age of Doubt."[4] The Victorians were certainly preoccupied with the experience, causes, and extent of religious doubt. Nevertheless, if selecting only one label, it would be more accurate to categorize nineteenth-century Britain as an Age of Faith. Part of the reason so many scholars have failed fully to grasp that it was an Age of Faith is that they misunderstand the import of the word "doubt." An Age of Doubt is very different from a Secular Age or an Age of Unbelief. In fact, the very notion of "doubt" presupposes a context where faith is the norm. To say that one doubts something is implicitly to address, or at least respond to, an audience that believes it. If something is simply known or implicitly assumed to be true or false, then the notion of doubt is irrelevant. One would not say,

[1]George MacDonald, *Thomas Wingfold, Curate* (New York: George Routledge and Sons, n.d. [orig. 1876]), 36.

[2]MacDonald, *Thomas Wingfold*, 30.

[3]MacDonald, *Thomas Wingfold*, 29.

[4]Recently that has even been the title of a book on the period: Christopher Lane, *The Age of Doubt: Tracing the Roots of Our Religious Uncertainty* (New Haven, CT: Yale University Press, 2011).

"People doubt that C. S. Lewis is the author of *The Princess and the Goblin*," but simply, "C. S. Lewis is not the author of *The Princess and the Goblin*." To put it even more forcefully, public expressions of religious doubt are always a sure and certain sign of the vitality of religious faith. If the populace was to become truly, completely secular, then there would no longer be a contemporary literature of doubt. The very skeptical books and organizations that scholars point to in order to show that faith was on the decline are actually evidence that it was robust. One might even say that doubt is essential to the drama of faith.[5]

There are two reasons why doubt loomed so large in the Victorian age. The first is that the legal and social restrictions on skepticism and unbelief where rapidly decreasing. Before the nineteenth century, one could not earn a university degree in England without declaring the truthfulness of the Thirty-Nine Articles. One could not become a Member of Parliament or hold most other political offices without affirming, at the very least, belief in God. In innumerable ways, to be known to be an unbeliever was to limit severely one's options and opportunities in life. Protestant Dissenters, however, ran a determined and highly successful campaign in the nineteenth century to dismantle these restrictions. Congregationalists, the denomination into which George MacDonald was ordained, gave the greatest leadership to this movement. Moreover, this move toward full religious freedom in society was prompted by evangelical reasons. Namely, the believer's weapons of warfare were not to be

[5]This paragraph draws on a previous article of mine: Timothy Larsen, "The Bible and Belief in Victorian Britain," *Cahiers victoriens et édouardiens* 76 (October 2012): 11-25.

carnal; it was unchristian to use coercion or worldly incentives to attempt to bolster the Christian faith.[6] In the past, people had generally kept their doubts to themselves so as not to hinder their prospects in society. In other words, doubt seemed so prominent in the nineteenth century because people felt freer than they had in the past to proclaim openly what they really thought.

The second reason why doubt loomed so large is that the nineteenth century was also the Evangelical Century.[7] Evangelicalism created a culture in which sincerity became essential. It was no longer enough merely to give formal assent to a doctrine for reasons of expediency. The great eighteenth-century skeptic David Hume, by contrast, even advised a fellow unbeliever to become a clergyman, arguing explicitly that there was no virtue in trying to be sincere in public life.[8] In the nineteenth century, however— thanks to the influence of evangelicalism—people generally believed that one should not affirm anything unless one truly believed it in one's heart. Expressions of doubt were therefore often a backhanded tribute to evangelical faith.

THE LEGEND OF THE HOLY DOUBTER

George MacDonald would champion a better way for Christians to respond to doubt. This began with the insight that questioning things is not wrong:

[6]Timothy Larsen, *Friends of Religious Equality: Nonconformist Politics in Mid-Victorian England* (Woodbridge, Suffolk: Boydell, 1999).

[7]David W. Bebbington, *The Dominance of Evangelicalism: The Age of Surgeon and Moody* (Downers Grove, IL: InterVarsity Press, 2005).

[8]David Hume, *Dialogues Concerning Natural Religion*, ed. Norman Kemp Smith (Indianapolis: Bobbs-Merrill Co., 1947), 40.

"Ma'am," said Curdie, "may I ask questions?"

"Why not, Curdie?"

"Because I have been told, ma'am, that nobody must ask the king questions."

"The king never made that law," she answered, with some displeasure. "You may ask me as many as you please."[9]

Questioning can be the first step toward a settled assurance: "The first sign of the coming capacity and the coming joy, is the anxiety and the question."[10] This leads on to the more general point that it is not inherently bad to have doubts. One reason why this is true is because doubt is not necessarily a choice:

"Nursie," said the princess, "why won't you believe me?"

"Because I can't believe you," said the nurse, getting angry again.

"Ah! then, you can't help it," said Irene, "and I will not be vexed with you any more. I will give you a kiss and go to sleep."[11]

Even questions that have an accusatory edge to them might be positive and productive in the end: MacDonald observes that complaints directed against God demonstrate a passionate engagement that can lead on to a healthy faith and are thus a far better portent of the future than spiritual indifference.[12]

MacDonald is particularly concerned to counteract the pernicious influence of Christians who react to confessions of doubt with condemnation, punishment, and accusations. In *Wilfrid*

[9]George MacDonald, *The Princess and Curdie* (London: Puffin Books, 1994 [orig. 1882]), 54.

[10]MacDonald, *Thomas Wingfold*, 551.

[11]George MacDonald, *The Princess and the Goblin* (New York: A. L. Burt, n.d. [orig. 1872]), 32.

[12]George MacDonald, *What's Mine's Mine* (London: Kegan Paul, n.d. [orig. 1886]), 291.

Cumbermede, Charley is a youth who lacks religious certitude, but he knows better than to try to discuss his concerns with his clergyman father: "He would speak to me as if I were the very scum of the universe for daring to have a doubt."[13] Repeatedly, when MacDonald's characters express their uncertainties to the vocal champions of religion, instead of being met with pastoral support and encouragement, they are reviled and rejected as heretics and atheists.[14] Great-Great Grandmother Irene, by contrast, knows better than to turn on doubters with displeasure: "I'm not vexed with you, my child—nor with Lootie either . . . when you had all but made up your mind that I was a dream, and no real great-great-grandmother.—You must not suppose I am blaming you for that. I dare-say you could not help it."[15] Likewise the saintly Rachel in *Thomas Wingfold*, though herself strong in faith, knows better than "to condemn doubt as wicked."[16]

In fact, far from being a sign of wickedness, MacDonald insisted that doubting was often an indication of a good and noble character. One of the most famous and emblematic articulations of Victorian doubt was—and still is for scholars today—Tennyson's *In Memoriam*, especially this stanza:

Perplext in faith, but pure in deeds,
At last he beat his music out.

[13]George MacDonald, *Wilfrid Cumbermede: An Autobiographical Story*, new edition (London: Kegan Paul, Trench, Trübner & Co., n.d. [orig. 1872]), 172-73.

[14]George MacDonald, *Within and Without* (New York: Scribner, Armstrong & Co., 1872 [orig. 1855]), 24, 75.

[15]MacDonald, *Princess and the Goblin*, 124, 175.

[16]MacDonald, *Thomas Wingfold*, 264.

There lives more faith in honest doubt,
Believe me, than in half the creeds.[17]

"Honest doubt" became a catch phrase, and it implied more than just doubt candidly avowed but rather that the doubt was actually a manifestation of the person's fundamental honesty and therefore marked them as worthy of our respect. We are told of our no-longer-carefree curate that he was finding the right path "now that Thomas had begun to doubt like an honest being."[18] It was a departure from the narrator's usual habit to refer to Wingfold by his first name, and this was presumably done to underline the decision to name him after the apostle known as Doubting Thomas, the patron saint of all those who are not yet convinced. *In Memoriam* is a book-length poem, yet MacDonald was so pleased with it that in the very year it was published he patiently copied the whole thing out by hand as a birthday present for his wife, Louisa.[19] Moreover, while many scholars treat it as a prime example of loss-of-faith literature, MacDonald would refer, in the Christian language of the community of faith, to "our beloved brother Tennyson in his book *In Memoriam*."[20] MacDonald even came to know Tennyson personally. The MacDonalds' London home offered a good view of the Thames and, delightfully, one year the Poet Laureate even gatecrashed their garden party so he too could watch the Oxford and Cambridge Boat Race.[21]

[17]Alfred Tennyson, *Poems*, with an introduction by Elizabeth Sharp (London: Walter Scott, n.d. [1899]), 195. *In Memoriam* was first published in 1850.

[18]MacDonald, *Thomas Wingfold*. 71.

[19]William Raeper, *George MacDonald* (Batavia, IL: Lion, 1987), 81.

[20]George MacDonald, *The Miracles of Our Lord* (New York: George Routledge and Sons, n.d. [orig. 1870]), 216-17.

[21]Raeper, *George MacDonald*, 336.

MacDonald's eyes of faith were always seeing religion in people whom others saw only as skeptics. He named Tennyson as the premier figure in that "noble band of reverent doubters" who were not to be conflated with scoffers.[22] Others in this worthy fraternity included Matthew Arnold and Arthur Hugh Clough, whose poem "The Questioning Spirit" MacDonald singled out for praise. In the eyes of most people, an obvious example of a religious scoffer was Mark Twain. MacDonald, however, struck up a hearty friendship with the satirist from Missouri. They visited each other in America and England and, in a moment of likeminded enthusiasm, imagined that they might collaborate on a novel. Twain's children avidly read and re-read *At the Back of the North Wind* until their copy disintegrated. Belying his reputation as an irreverent unbeliever, MacDonald apparently found Mark Twain to be a "deeply religious" man.[23] Even P. B. Shelley, who scandalized the respectable by becoming one of the first figures in British elite society openly to avow atheism, MacDonald discerned to be someone whose professed unbelief was a protest against unchristian things that were said and done in the name of religion. He even went so far as to claim that Shelley's writings bore signs of a subterranean commitment to "the very essence of Christianity."[24]

In his fiction, MacDonald returned again and again to this motif of the legend of the holy doubter. The most unflinching

[22]George MacDonald, *England's Antiphon* (London: Macmillan, n.d. [orig. 1874]), 326.

[23]Greville MacDonald, *George MacDonald and His Wife* (London: George Allen & Unwin, 1924), 457. It seems more likely that Greville gained this impression from his father than that he inserted into this biography a pet theory of his own.

[24]George MacDonald, *A Dish of Orts: Chiefly Papers on the Imagination and Shakespeare* (London: Edwin Dalton, 1908), 271.

of these portraits is the character of Charley in *Wilfrid Cumbermede*. Defying assumptions about Victorian sentimentality in didactic Christian novels (although readers are meant to admire and sympathize with him), far from having a happy ending in which he finds a deeper, truer faith—spoiler alert—Charley's chronically unsettled condition culminates in his suicide. Nevertheless, even this is just an extreme example of evangelical sincerity gone awry. From his evangelical clergyman father Charley "had inherited a conscience of abnormal sensibility."[25] Charley's case reveals that sometimes he who cares much, doubts much: "It was the very love of what was good that generated in him doubt and anxiety."[26] To care with such passionate earnestness about the truthfulness of Christianity is, for those who have eyes to see, itself a sign of faith, even if this faith is only the size of mustard seed: "There was always a certain indescribable dignity about what he said which I now see could have come only from a *believing* heart."[27] Similarly, there is the "sad holy doubt" of Ericson in *Robert Falconer*: "For Ericson's, like his own, were true and good and reverent doubts, not merely consistent with but in a great measure springing from devoutness and aspiration. Surely such doubts are far more precious in the sight of God than many beliefs?"[28]

At the other end of the spectrum from Charley—who, to reiterate, never does find assurance in this world—is Ian in

[25]MacDonald, *Wilfrid Cumbermede*, 139.
[26]MacDonald, *Wilfrid Cumbermede*, 182.
[27]MacDonald, *Wilfrid Cumbermede*, 303.
[28]George MacDonald, *Robert Falconer* (London: Hurst and Blackett, n.d. [orig. 1868]), 258.

What's Mine's Mine. The reader gains the impression that he is a doubter, but as the novel goes along it becomes clear that Ian is primarily objecting to empty religious forms and false theological formulas and that he not only already has a real faith but is an exemplary Christian. Nevertheless, Ian still serves to remind us that when we encounter religious doubt, it might actually be a sign of something life-giving and true rather than destructive and false:

> Ian was one of those blessed few who doubt in virtue of a larger faith. While its roots were seeking a deeper soil, it could not show so fast a growth above ground. He doubted most about the things he loved best, while he devoted the energies of a mind whose keenness almost masked its power, to discover possible ways of believing them. To the wise his doubts would have been his best credentials; they were worth tenfold the faith of most. It was truth, and higher truth, he was always seeking.[29]

The quintessential MacDonald leading characters, however, are recurringly ones who really do have fundamental religious doubts but whose quest for truth leads them on to a deeper, more profound faith. As we encounter such stories in real life *in media res*, MacDonald wanted us to be able to discern the potential upside of doubt. In his *Unspoken Sermons*, he gave pastoral reassurance to his readers that their periods of doubt, which so alarm them, might be some of the best of times in their seeking after truth and spiritual life.[30] Moreover,

[29]MacDonald, *What's Mine's Mine*, 62.
[30]George MacDonald, *Unspoken Sermons: Series I, II, and III* (Whitethorn, CA: 2004 [orig. 1867, 1885, and 1889]), 402.

a man may be haunted with doubts, and only grow thereby in faith. Doubts are the messengers of the Living One to rouse the honest. They are the first knock at our door of things that are not yet, but have to be understood. . . . Doubt must precede every deeper assurance.[31]

Likewise, in *The Miracles of Our Lord*, MacDonald expounded upon the plea recorded in Mark 9:24, "help thou mine unbelief," arguing that this text should become a kind of life verse for an Age of Doubt:

It is the very triumph of faith. The unbelief itself cast like any other care upon him who careth for us, is the highest exercise of belief. It is the greatest effort lying in the power of the man. No man can help doubt. The true man alone, that is, the faithful man, can appeal to the Truth to enable him to believe what is true, and refuse what is false. How this applies especially to our own time and the need of the living generations, is easy to see.[32]

MacDonald even expressed a providential view of the Age of Doubt, arguing that it "no doubt is needful, and must appear some time in the world's history. . . . No doubt it has come when it must, and will vanish when it must."[33] In *Lilith*, Mr. Vane confesses penitently that he still has questions and uncertainties. Father Adam graciously reassures him "thou canst, not but doubt, and art blameless in doubting"; "Thou doubtest because thou lovest the truth."[34] In a letter to his father, MacDonald reflected that

[31]MacDonald, *Unspoken Sermons*, 354-55.

[32]MacDonald, *Miracles*, 178.

[33]MacDonald, *Miracles*, 33.

[34]George MacDonald, *The Visionary Novels of George MacDonald*, ed. Anne Fremantle (New York: Noonday Press, 1954), 242. *Lilith* was first published in 1895.

"real earnestness is scarcely to be attained in a high degree without doubts & inward questionings."[35]

Not only does MacDonald often discern doubt to be covert evidence of faith, but he completes the paradox by suspecting that a posture of overweening certitude could be a secret sign of doubt. Perhaps Charley's dogmatic, scolding clergyman father is not so much a paragon of faith as someone with so little faith that he does not think his religion can withstand scrutiny: "Do you know, Wilfrid—I *don't* believe my father is quite sure himself, and that is what makes him in such a rage with anybody who doesn't think as he does. He's afraid it mayn't be true after all."[36] For this reader at least, when the self-righteous Mrs. Elton in *David Elginbrod* asserts breezily in one breath that the Bible has been confirmed by both contemporary archaeological discoveries *and* recent paranormal occurrences, one suspects that she is protesting too much.[37] This paradox is encapsulated in the triumphant, final stanza of MacDonald's long poem, "The Disciple":

> Even of thy truth, both in and out,
> That so I question free:
> The man that feareth, Lord, to doubt,
> In that fear doubteth thee.[38]

[35]George MacDonald to his father, 16 November 1853, *An Expression of Character: The Letters of George MacDonald*, ed. Glenn Edward Sadler (Grand Rapids: Eerdmans, 1994), 69.

[36]George MacDonald, *Wilfrid Cumbermede*, 173.

[37]George MacDonald, *David Elginbrod* (London: Hurst and Blackett, n.d. [orig. 1863]), 208.

[38]George MacDonald, *The Disciple, and Other Poems* (London: Strahan and Co., 1868 [orig. 1867]), 49.

THE ROMANTIC ROAD

As the raven reminds us in *Lilith*, a door need not be just a way in: it can also be a way out.[39] Secular scholars tend to assume that doubt is just a way in to unbelief, but the spiritual wisdom of George MacDonald is that it can also be a way out. As I have explored elsewhere, there was not just a Victorian "crisis of faith" but also a "crisis of doubt," that is, many intellectuals and earnest thinkers found that their doubts led them on not to a final position of agnosticism or atheism, but rather to a mature, radiant Christian faith.[40] Just as MacDonald represents the Age of the Incarnation, so his writings very much participate in and explore the crisis of doubt which leads on to a tested and sure Christian commitment. In *Robert Falconer* we read of "the embryo faith, which, in minds like his, always takes the form of doubt."[41] In *Annals of a Quiet Neighbourhood* we hear this word of hope: "A man may be on the way to the truth, just in virtue of his doubting. I will tell you what Lord Bacon says ... : 'So it is in contemplation: if a man will begin with certainties, he shall end in doubts; but if he will be content to begin with doubts, he shall end in certainties.'"[42]

Having observed that questioning and uncertainty can be a good sign as a proper starting point, much of MacDonald's writings are then given over to commending to honest doubters a viable path forward toward faith in God and in Christ. The door of doubt

[39]MacDonald, *Visionary Novels*, 11.

[40]Timothy Larsen, *Crisis of Doubt: Honest Faith in Nineteenth-Century England* (Oxford: Oxford University Press, 2006).

[41]MacDonald, *Robert Falconer*, 93.

[42]George MacDonald, *Annals of a Quiet Neighbourhood* (New York: George Routledge and Sons, 1869 [orig. 1867]), 52.

leads out as well as in. When I was growing up, I was taught the "Roman road" to salvation, and I have come to think of MacDonald's way as the Romantic road. The shift from the Age of Atonement to the Age of the Incarnation explored in the first chapter also corresponded to a shift from a culture inflected by the Enlightenment to one imbued with Romanticism.[43] In the dogmatic Christianity of the Age of Atonement, there was a tendency to be suspicious of earthly passions on the grounds that they were potentially idolatrous, rivals to the supreme place that the Almighty alone should have in one's heart. MacDonald's paternal grandmother, Isabella, burned her son's violin out of fear that it was a spiritual snare, a scene fictionalized in *Robert Falconer*, where the musical instrument in the midst of its destruction is referred to as "the burning idol."[44] And even MacDonald's own father, in a weak moment, confiscated a novel by Sir Walter Scott out of anxiety that it might deflect his boy from a life of faith.[45]

The holy logic of the incarnation, however, is that God himself has sanctified the earthly by taking on flesh. In a letter to his wife, MacDonald rhapsodized about the "God of mountain lands, and snowdrops, of woman's beauty and man's strength—the God and Father of our Lord Jesus Christ."[46] On rare occasions, MacDonald concedes that what is not inherently evil may nevertheless become an idol to someone. Notably, in *Within and Without* the lecherous

[43]To place MacDonald and this theology in this context, see Mark Hopkins, *Nonconformity's Romantic Generation: Evangelical and Liberal Theologies in Victorian England* (Milton Keynes: Paternoster, 2004).

[44]Raeper, *George MacDonald*, 19; MacDonald, *Robert Falconer*, 151.

[45]Raeper, *George MacDonald*, 106.

[46]George MacDonald to his wife, 14 July 1855, *Expression of Character*, 94.

Lord Seaford has done this with Lilia: "O what is God to me? . . . Thou art enough to fill my heart."[47] This was an easy exception for MacDonald to allow, however, as it was not only idolatrous but adulterous, and the proper balance of the incarnational universe is restored once again upon Seaford's repentance: "I have sinned against the Soul of love and beauty, / Denying Him in grasping at his work."[48] Less rigged, Alister in *What's Mine's Mine*—even though a fundamentally good, Christian man—must nevertheless face up to the fact that his possessive attitude towards his ancestral land is a spiritual hindrance.[49] These are exceptions, however: MacDonald's overwhelming message was that earthly passions lead us towards God rather than away from him. Just a few pages earlier in *What's Mine's Mine* he had expressed this in the most provocative of terms: "Even the worship of Nature herself might be an ennobling idolatry, so much is the divine present in her."[50] Nature is often herself a character in MacDonald's novels whom his protagonists discover like meeting someone who will become your new best friend—and this newly acquired, passionate commitment to Nature is often identified as an important stage on the Romantic road to salvation. In *Robert Falconer*, for example, we get a full chapter with the anthropomorphizing title "Nature Puts in a Claim."[51] Moreover, MacDonald even made the connection with the Romantic literary movement explicit. Here, for instance, is a reflection in *Wilfrid Cumbermede*: "The fact is I was coming

[47]MacDonald, *Within and Without*, 108.
[48]MacDonald, *Within and Without*, 186.
[49]MacDonald, *What's Mine's Mine*, 244-45.
[50]MacDonald, *What's Mine's Mine*, 241.
[51]MacDonald, *Robert Falconer*, 119.

in for my share in the spiritual influences of Nature, so largely poured on the heart and mind of my generation. The prophets of the new blessing, Wordsworth and Coleridge, I knew nothing of. Keats was only beginning to write."[52]

Reverence for Nature awakens in Wilfrid worship for Almighty God, the Creator and Sustainer of all things. When Charley commits suicide, his father has him buried in what he thinks of as unconsecrated ground, oblivious to the deeper truth that there can be no such thing because the earth itself is holy.[53] Charley had also lacked this blessed assurance and thus was not able to travel even this far down the Romantic road. Suffering from a diseased Nominalism in MacDonald's Platonic Paradiso, not only did Charley not have the faith to move mountains, he did not even have enough faith to believe in them: "'Oh, Willie,' he said to me one day, 'if I could but believe in those mountains, happy I should be! But I doubt, I doubt they are but rocks and snow.'"[54]

Along with Nature, MacDonald also extolled music, poetry, human beauty, and romantic love as potentially leading one towards God. Contrariwise, in *Wilfrid Cumbermede* the reader is put on guard against Clara when she makes "irreverent" comments about both Nature and—yet more sacrilege!—a Shelley poem.[55] Like the ennobling power of Nature, the capacity of love for a particular human being to lead on to the love of God was one of MacDonald's steadfast convictions. He experienced this in his

[52]MacDonald, *Wilfrid Cumbermede*, 131.
[53]MacDonald, *Wilfrid Cumbermede*, 445.
[54]MacDonald, *Wilfrid Cumbermede*, 141.
[55]MacDonald, *Wilfrid Cumbermede*, 165-66.

own life with Louisa, and their marriage does seem to have been a worthy, Christian model of enduring, intense, faithful, romantic love. They had eleven children, which Louisa, with undiminished ardor and energy, pronounced ruefully to be "the wrong side of a dozen."[56] Her husband wrote to her in 1853, "Thank you dear love for your much precious love—the most precious thing I have—for I will not divide between the love of God directly to me and that which flows through you."[57] She was a channel of divine love, not a rival to it. In *What's Mine's Mine*, Mercy's romantic attraction to Alister puts her on the Romantic road to salvation: "It was love, in part, that now awoke in Mercy a hunger and thirst after heavenly things. This is a direction of its power little heeded by its historians."[58] At his brashest, MacDonald could suggest that the existence of a good and beautiful woman is itself a refutation of atheism: "The very presence of such a being gives Unbelief the lie."[59] Moreover, he avers, why would someone accept a message as a divine revelation on the testimony of a good angel but not on the testimony of a good woman? With impeccable theological lucidity he observes, is not a woman greater than an angel?[60]

While we are on the subject of love, let me add here that MacDonald often looked for other terms that could take some of the unwieldy, burdensome weight which had piled up over the centuries off of the words "faith" and "belief." He sensed that

[56]Raeper, *George MacDonald*, 259.
[57]George MacDonald to his wife, 7 September 1853, *Expression of Character*, 63.
[58]George MacDonald, *What's Mine's Mine*, 263.
[59]MacDonald, *Robert Falconer*, 230.
[60]MacDonald, *Robert Falconer*, 251.

the Protestant commitment to *sola fide* had unwittingly led to an unhealthy introspection regarding how much belief one possessed. This was a mistake. The way of salvation, as we shall see, involves looking to Jesus, not oneself. The person who looks to Jesus and says "help thou mine unbelief" is on a far surer track than the one who is doing an internal audit of their personal supply of ready faith. One must avoid "that diseased self-consciousness which nowadays is always asking, 'Have I faith? Have I faith?' searching, in fact, for grounds of self-confidence."[61] Therefore, in a sentence where a person would traditionally speak of *faith*, MacDonald would often attempt to replace it with another word to see if this substitution could help someone see a way forward in their spiritual journey. As we will discuss more later on, two crucial words in this regard were *trust* and *obedience*. To begin where we recently arrived, however, *love* was one such word. Maybe the opposite of doubt is not faith, but love; after all, "he who loves most can believe most."[62] Faith has its place, but the greatest of these is love. This insight from 1 Corinthians 13, in turn, reminds us that "hope" also has its place. MacDonald often leaned on *hope* as a word that paired a good heart and disposition with humility regarding one's own ability to have faith. When Falconer observes that his friend does not believe in God, he receives this earnest rely: "'Don't say that, Robert,' Ericson returned, in a tone of pain with which no displeasure was mingled. 'But you are right. At best I only hope in God.'"[63]

[61]MacDonald, *Miracles*, 100-101.

[62]MacDonald, *Miracles*, 129.

[63]MacDonald, *Robert Falconer*, 239.

Once Wingfold has found his way to life in Christ, Helen asks him to be her guide along the same path: "Will you take me for a pupil—a disciple—and teach me to believe—or hope, if you like that word better—as you do?"[64] MacDonald's last volume of sermons was given the lovely and fitting title, *The Hope of the Gospel.*[65]

I Am the Door

The core of MacDonald's pastoral counsel for someone beset with doubts was to look to Jesus, the author and finisher of our faith (Heb 12:2). To put this negatively, the Scottish sage was concerned that even spiritual resources that are good and helpful in their proper place might become a befuddling, dark wood that would keep seekers from seeing the Tree of Life. One needed to set aside perplexing theologies and theologians and start afresh with the Son of God incarnate. As a folky draper and Dissenting deacon reflects in *Thomas Wingfold, Curate,* "But I will avoid theology, for I have paid more regard to that than has proved good for me. Suffice it to say that I was now driven from the tests of the theologians to try myself by the words of the Master—he must be the best theologian after all, mustn't he, sir?"[66]

Moreover, MacDonald had a strong sense that there was a canon within the canon. Seekers are confused because they are told to treat every part of the Bible as equally relevant to their quest for salvation. As Ian wearily explains to his pontificating parent, "The

[64]MacDonald, *Thomas Wingfold*, 665.
[65]George MacDonald, *The Hope of the Gospel* (London: Ward, Lock & Co., 1892).
[66]MacDonald, *Thomas Wingfold*, 253.

Bible is a big book, mother, and the things in it are of many sorts."[67] MacDonald illustrates this humorously by poking fun at a lay preacher who memorized the first nine chapters of 1 Chronicles precisely because only a person of sound doctrine, he fancied, would be convinced that these tedious genealogies were worth prioritizing in this way.[68] More seriously, some parts of this "big book" can trouble and vex those whose faith is uncertain. This kind of unsettlement, however, can be not only avoided but counteracted by approaching the Bible aright. Again we turn to *Lilith*: "'A book,' he said louder, 'is a door in, and therefore a door out.'"[69] MacDonald was so anxious to privilege the New Testament that encountering some of his works in isolation might make one wonder if he was a Marcionite. It is often the Age-of-Atonement figures in his novels who are depicted reading the Old Testament and quoting it authoritatively. Falconer's grandmother prays aloud at household devotions, "Let the rod of thy wrath awake the worm of their conscience, that they may know verily that there is a God that ruleth in the earth."[70] Charley's father, alas, is apt to interact with his oversensitive, despairing son by larding his conversation with pronouncements such as "Depart from me, all evil-doers. O Lord! do I not hate them that hate thee?"[71]

By contrast, when spiritual progress is being made, MacDonald often does not tell us that the character is reading "the Bible," but rather specifically "the New Testament." The good clergyman in

[67]MacDonald, *What's Mine's Mine*, 60.
[68]MacDonald, *Robert Falconer*, 42.
[69]MacDonald, *Visionary Novels*, 40.
[70]MacDonald, *Robert Falconer*, 36-37. See Lam 3:1 and Ps 59:13.
[71]MacDonald, *Wilfrid Cumbermede*, 177. The second sentence is from Ps 139:21.

Annals of a Quiet Neighbourhood seeks edification by walking into the countryside to "be alone with nature and my Greek Testament."[72] It is unlikely that a poor servant would have a duplicate book, and we know she does have a full Bible because she later reads from Isaiah, yet in *David Elginbrod* MacDonald was so anxious to emphasize this point that he wrote implausibly, "Margaret got a New Testament and read."[73] More specifically, MacDonald commended the Gospels. Even this clergyman with his Greek text hits a point in his spiritual journey when, to his own surprise, he "could not read the Epistles at all."[74] MacDonald gave this advice in a letter:

> My dear & honored father—if I might say so to you—will you think me presumptuous if I say—leave the Epistles & ponder *The Gospel*—The story about Christ. Infinitely are the Epistles mistaken because the Gospels are not understood. . . . The Gospels form the sum & substance of the apostles' teaching, & preaching.[75]

For MacDonald, the Gospel texts that record the very words of Jesus formed the core of cores of the biblical canon. George MacDonald was the first Red Letter Christian. The character of Thomas Wingfold, of course, is being offered as a how-to model for navigating doubts. He decides at one point that even in the Gospels, he could get sidetracked into spiritually unproductive issues such as "the discrepancy in the genealogies." He concludes that his focus needed to be on Christ's words: "But when it came

[72]MacDonald, *Annals*, 306.

[73]MacDonald, *David Elginbrod*, 359.

[74]MacDonald, *Annals*, 127.

[75]George MacDonald to his father, 29 April 1853, *Expression of Character*, 59. Italics in original.

to the perplexity caused by some of the sayings of Jesus himself, it was another matter. He *must* understand these, he thought, or fail to understand the man."[76] MacDonald the sermonizer could preach this in the most emphatic terms: "To understand the words of our Lord is the business of life."[77] Or in the tradition of the sentimental deathbed scene which was so beloved by Victorians, we read in *Robert Falconer*, "From that day to the last, as often and as long as the dying man was able to listen to him, he read from the glad news just the words of the Lord."[78] Again, it is important to recognize that the purpose of this pastoral advice was to guide doubters into fixing their eyes upon Jesus and thereby being transformed by him. The door does not just lead in to unbelief, it can be a door out as well. And when we attend to the sayings of the Master, we find that in John's Gospel he proclaims, "I am the door: by me if any man enter in, he shall be saved" (Jn 10:9). As MacDonald beautifully observes in one of his *Unspoken Sermons*, "Christ is the way out, and the way in."[79]

It is important to underline that MacDonald was not jettisoning other resources, but only listing the ones it would be most helpful for the perplexed to prioritize. His advice should not be confused with a kind of Jefferson Bible project; MacDonald was not really a Marcionite. Thus, if one takes his rings of priority in reverse, the first thing to reaffirm is MacDonald's commitment to the Gospels as a whole rather than just the words of Christ. In fact,

[76]MacDonald, *Thomas Wingfold*, 188-89.
[77]MacDonald, *Unspoken Sermons*, 79.
[78]MacDonald, *Robert Falconer*, 42.
[79]MacDonald, *Unspoken Sermons*, 363.

George MacDonald had a notably conservative and high view of the veracity of the Four Gospels. Again and again, he denied that the so-called synoptic problem compels us to assume that one or more Gospel writer must have been in error: "No perplexity arises from the difference between the accounts, for there is only difference, not incongruity."[80] Or again, from another book, "There is not for that the smallest necessity for rejecting either account; they blend perfectly, and it is to me a joy unspeakable to have both. Put together they give a completed conversation."[81] MacDonald also was not at all inclined toward higher biblical criticism. He assumed that the traditionally identified authors of the Gospels are the correct ones. Not only did he believe that John's Gospel was written by the apostle of that name who was an eyewitness of the events he describes, MacDonald even endearingly argues that, as it was the last Gospel to be written, we can trust its accuracy all the more because John had had more time to think through what precisely had happened.[82] As a convert to Christ, the Reverend Thomas Wingfold is willing to admit that the story of the woman caught in adultery is not part of the original text of John's Gospel but rather "an interpolation." This concession, however, has no import in terms of how we receive this material: "It all matters nothing, so long as we can believe it; and true it must be, it is so like him all through."[83]

[80]MacDonald, *Miracles*, 75.

[81]MacDonald, *Unspoken Sermons*, 170.

[82]MacDonald, *Unspoken Sermons*, 435. For the deep love for the Fourth Gospel in nineteenth-century Britain, see Michael Wheeler, *St. John and the Victorians* (Cambridge: Cambridge University Press, 2012).

[83]MacDonald, *Thomas Wingfold*, 546-47.

It is certainly not the case that MacDonald pointed people to the sayings of Christ because he did not believe in the miracles. Quite the opposite, he wrote *The Miracles of Our Lord* to go out of his way to defend them all. Belying any simple assumption that George MacDonald was a modernizer theologically, he even confidently proclaimed that he had "no difficulty" taking literally the accounts of demonic possession.[84] MacDonald championed the literal truthfulness of every miraculous account in the Gospels, each in turn—even the story of finding the coin in the fish which he admits to many people sounds like "the tales of eastern fiction."[85] Most of all, he was a strong believer in the bodily resurrection of Jesus Christ.[86] When two of their children died within a year of each other, MacDonald was able to draw comfort from this great, central miracle of the Christian faith: "If I did not hope in the risen Christ, where should my life be now?"[87] MacDonald had a deep and unwavering conviction that there was life after death. In one of the more delicious scenes in *Thomas Wingfold, Curate*, Helen explains to the scoffing, infidel Bascombe that the immortality of the soul is a doctrine for lovers. His skepticism is a romantic turn off: "George, I never could love a man who believed I was going to die forever. . . . It may be only a whim—I can prove nothing any more than you—but I have a—whim then—to be loved as an immortal woman, the child of a living God."[88]

[84]MacDonald, *Miracles*, 129.

[85]MacDonald, *Miracles*, 248-49.

[86]MacDonald, *Miracles*, 260: "For distinctly do I hold that he took again the same body in which he had walked about on the earth, suffered, and yielded unto death. In the same body—not merely the same form."

[87]George MacDonald to his stepmother, 18 August 1879, *Expression of Character*, 298.

[88]MacDonald, *Thomas Wingfold*, 656-57.

After being transformed by the Gospels, one can then go on to profit from the rest of the New Testament. Although the clergyman in *Annals of a Quiet Neighbourhood* forsakes the Epistles for a season, once he grasped the witness of the Gospels he was able to return to them and understand them aright.[89] MacDonald himself found much joy later in life in reading the New Testament in Greek every day and observed in particular that many parts of the Epistles that he had found confusing in the past were now becoming clear to him.[90] And the same holds true for the Old Testament. MacDonald had a particular love of the Psalms, Job, and Isaiah. He preached sermons from Old Testament texts and had sympathetic characters do so in his novels. When his son Greville was uncertain as to his vocational path, MacDonald wrote him a letter of spiritual counsel in which all of the proof texts were from the Hebrew Scriptures, including "in quietness and confidence shall be your strength" (Is 30:15).[91] Perhaps not least telling is the prominence of the Old Testament in *Lilith*. Just as C. S. Lewis was convinced that Father Christmas exists even in Narnia, so George MacDonald believed that the Word of God as given in Holy Scripture is living, enduring, and active even in "the region of the seven dimensions" where skeletons and phantoms fight in mad confusion.[92] Not only do characters in *Lilith* speak of Adam, Noah, Lot's Wife, and Rachel, but direct scriptural quotations recur throughout this pioneering work of fantasy literature,

[89]MacDonald, *Annals*, 127-28.
[90]George MacDonald to Georgina Cowper-Temple, 20 March 1879, *Expression of Character*, 292.
[91]George MacDonald to Greville MacDonald, 6 April 1884, *Expression of Character*, 311.
[92]MacDonald, *Visionary Novels*, 20, 53-54.

including these words of spiritual comfort: "Weeping may endure for a night, but joy cometh in the morning" (Ps 30:5).[93]

But we have gotten ahead of ourselves. MacDonald wanted doubters to focus on the Christ of the Gospels because he was convinced that if they did, they would discover Jesus of Nazareth to be distinctively good. And to discern that Christ is worthy is to receive a self-authenticating revelation. There was a remarkably widespread conviction in the Victorian age that the portrait of Jesus of Nazareth found in the canonical Gospels was too good not to be true. Even one of the leading unbelievers of the nineteenth century, the Utilitarian philosopher J. S. Mill, accepted the validity of this apologetic argument: "It is of no use to say that Christ as exhibited in the Gospels is not historical. . . . Who among his disciples or among their proselytes was capable of inventing the sayings ascribed to Jesus or of imagining the life and character revealed in the Gospels?"[94] If even the "Saint of Rationalism" could find that argument persuasive, then our "St. Francis of Aberdeen" (as G. K. Chesterton dubbed the author of *Phantastes*) could feel he was on solid ground: "Jesus Christ did come, for no man could have invented him."[95] At the end of the novel, our redeemed curate testifies to his congregation that "in the story of Jesus I have beheld such grandeur—to me apparently altogether beyond the reach of human invention."[96]

[93]MacDonald, *Visionary Novels*, 82.

[94]John Stuart Mill, *Essays on Ethics, Religion and Society*, Collected Works of John Stuart Mill 10, ed. J. M. Robson (Indianapolis: Liberty Fund, 2006), 487. For the centrality of this argument for atheists and secularists who came to faith, see Timothy Larsen, *Crisis of Doubt*, esp. 243.

[95]George MacDonald to Greville MacDonald, 20 January 1889, *Expression of Character*, 341.

[96]MacDonald, *Thomas Wingfold*, 649.

Diamond reasons that North Wind must be real because "I couldn't be able to dream anything half so beautiful out of my own head."[97]

TRUST AND OBEY

If Christ is real, and he is discernably worthy and good, then the only fitting response is to trust him. This is a key MacDonald move: the question is not whether you understand it all, whether you believe it all, whether you have faith; the real question is a simple, existential one: Are you willing to trust him? So many of MacDonald's fairy tales and fantasies explore the theme of trusting even when you are being asked to act upon an improbable account that you cannot independently verify or even comprehend. Diamond does not understand why North Wind would sink a ship, and he does not resolve this quandary. Instead, he recognizes that he has discerned North Wind's character to be good and therefore it is right to trust her: "For I am sure you are kind. I shall never doubt that again."[98] Curdie's mother says she does not blame him for not being able to believe what Irene has told him, but she does blame him for denying what he did have enough evidence to know, namely that the young princess is an honest person of good character:

> "Perhaps some people can see things other people can't see, Curdie," said his mother very gravely. "I think I will tell you something I saw myself once—only perhaps you won't believe me either!"

[97]George MacDonald, *At the Back of the North Wind* (London: J. M. Dent & Sons, 1959 [orig. 1871]), 311.
[98]MacDonald, *North Wind*, 62.

"Oh, mother, mother!" cried Curdie, bursting into tears; "I don't deserve that, surely!"

. . . "You don't think I'm doubting my own mother!"[99]

Likewise there is this exchange between an old farmer and Anodos in *Phantastes*:

"Now, you would hardly credit it, but my wife believes every fairy tale that ever was written. I cannot account for it. She is a most sensible woman in everything else."

"But should not that make you treat her belief with something of respect, though you cannot share in it yourself?"[100]

MacDonald was a bearded prophet crying out, "Who hath believed our report? and to whom is the arm of the Lord revealed?" (Is 53:1).

This is the one thing needful: "The only and the greatest thing man is capable of is Trust in God."[101] To fail at this is indeed to fail to go through the door that leads out of Doubting Castle: "Distrust is atheism, and the barrier to all growth."[102] By contrast, those who trust Christ need not be unduly troubled by their uncertainties about religious claims: "Against my fears, my doubts, my ignorance, / I trust in thee, O father of my Lord!"[103] This way of life is also self-authenticating. Taste and see that the Lord is good! As MacDonald wrote to a friend, "I will not say *believe*, for that is a big word, and it means so much more than my low

[99]MacDonald, *The Princess and the Goblin*, 265, 269.

[100]MacDonald, *Visionary Novels*, 307. *Phantastes* was first published in 1858.

[101]MacDonald, *Robert Falconer*, 353.

[102]MacDonald, *Unspoken Sermons*, 213.

[103]George MacDonald, *The Diary of an Old Soul* (London: George Allen & Uwin, 1922 [orig. 1880]), 138.

beginnings of confidence. But . . . the more we trust, the more reasonable we find it to trust."[104]

When Great-Great-Grandmother Irene asks Curdie to accept a mission, she explains what the sole qualifications for the task are: "It needs only trust and obedience."[105] Long before the beloved hymn "Trust and Obey" was published in 1887, George MacDonald had already developed this formula as the key to moving beyond one's doubts to become a true Christian. The question is not whether you are believing but whether you are obeying: "Faith is that which, knowing the Lord's will, goes and does it. . . . Instead of asking yourself whether you believe or not, ask yourself whether you have this day done one thing because he said, Do it, or once abstained because he said, Do not do it."[106]

Once again, a central theme of MacDonald's fantasy literature is the question of whether characters will trust and obey despite their uncertainties. In the chapter "I Am Sent" in *Phantastes*, Anodos is finally able to prove that he has learned obedience.[107] One might almost say that George MacDonald's love language was obedience: "'What do you want me to do next, dear North Wind?' said Diamond, wishing to show his love by being obedient."[108]

In *The Miracles of Our Lord*, MacDonald observes how often when Jesus intends to heal someone he gives them some action in which to be obedient even if the request is as simple as "stretch

[104]George MacDonald to Georgina Cowper-Temple, 19 December 1888, *Expression of Character*, 340.
[105]MacDonald, *Princess and Curdie*, 69.
[106]MacDonald, *Unspoken Sermons*, 99, 395.
[107]MacDonald, *Visionary Novels*, 229.
[108]MacDonald, *North Wind*, 90.

forth thine hand" or "take up thy bed."[109] Christ himself modeled this way of life for us: his entire mission on earth from beginning to end was to do the will of his Father.[110] It is not an accident that MacDonald's autobiographical poem about dealing with doubt was called "The Disciple." The question is not whether you profess faith in Christ but whether you are truly his disciple, whether or not you are actually following him: "It is a law with us that no one shall sing a song who cannot be the hero of his tale—who cannot live the song that he sings."[111] Those who think of themselves as Christians but are not doing the will of God are deceiving themselves. And so are those who think obedience is the last step, that as long as they have doubts to overcome they have not yet reached the stage of obedience. The truth is, they already know enough to trust and therefore to obey. The river actually flows the other way: "A man may say, 'How can I have faith?' I answer, 'How can you indeed, who do the thing you know you ought not to do, and have not begun to do the thing you know you ought to do? How should you have faith?'"[112]

MacDonald's great proof text for how to deal with doubts about the claims of Christianity was the very word of Jesus as recorded in John 7:17: "If any man will do his will, he shall know of the doctrine, whether it be of God."[113] "When people speculate instead of obeying, they fall into endless error."[114] "Oh, the folly of any

[109]MacDonald, *Miracles*, 53, 58.
[110]MacDonald, *Thomas Wingfold*, 489.
[111]MacDonald, *Within and Without*, 90.
[112]MacDonald, *Miracles*, 113.
[113]MacDonald, *Robert Falconer*, 303.
[114]MacDonald, *What's Mine's Mine*, 110.

mind that would explain God before obeying him!"[115] "O taste and see that the Lord is good; blessed is the man that trusteth in him" (Ps 34:8). Unbelief is overcome by trusting and obeying:

I search my heart—I search, and find no faith.
Hidden He may be in its many folds—
I see him not revealed in all the world;
Duty's firm shape thins to a misty wraith.
No good seems likely. To and fro I am hurled.
I have no stay. Only obedience holds:—
I haste, I rise, I do the thing he saith.[116]

And likewise here is a stanza from *Within and Without*:

Alas, my Lilia! But I'll think of Jesus,
Not of thee now; Him who hath led my soul
Thus far upon its journey home to God.
By poor attempts to do the things He said,
Faith has been born.[117]

MacDonald therefore also emphasized knowing what one's own particular work in this world is and doing it. Working faithfully is the way of obedience and therefore the way of faith. Mossy must do the work that has been set before him; so must North Wind; and so must you and I.

THE HERO OF HIS OWN TALE

The path set out in this chapter—to respond to doubts by studying the story and words of Christ and thereby learn to trust him and

[115]MacDonald, *Unspoken Sermons*, 504.
[116]MacDonald, *Diary of an Old Soul*, 24.
[117]MacDonald, *Within and Without*, 94.

then to act on this trust by following him in obedience—is the one that our young clergyman travels down in *Thomas Wingfold, Curate*. And as with so many of MacDonald's writings, that novel was written "that ye might believe that Jesus is the Christ, the Son of God; and that believing ye might have life through his name" (Jn 20:31). In the end, our modern Doubting Thomas is born again: "He had burst the shell of the mortal and was of those over whom the second death hath no power. The agony of the second birth was past, and he was a child again—only a child, he knew, but a child of the kingdom."[118] And this was the experience of many people in the Victorian age. MacDonald received a letter from an atheist who reported that he had become a believer through reading his books.[119] An eminent Victorian, the art critic and sage John Ruskin, was one of MacDonald's closest friends. Ruskin lost his faith, but the author of *Thomas Wingfold, Curate* was confident that his friend would eventually find the door that leads out of unbelief, and his faith was rewarded. Thus Ruskin himself represents the pattern of a crisis of doubt that leads on to becoming a true disciple of Jesus Christ.[120]

And George MacDonald knew whereof he spoke. In response to a lady who wanted to know how much faith he still had in classic Christian teaching, he testified, "With all sorts of doubt I am familiar, and the result of them is, has been, and will be, a widening of my heart and soul and mind to greater glories of the

[118]MacDonald, *Thomas Wingfold*, 645.

[119]Greville MacDonald, *George MacDonald and His Wife*, 478.

[120]There is still a need for a spiritual biography of Ruskin, but there is a scholarly meditation on the religious themes in his work: Michael Wheeler, *Ruskin's God* (Cambridge: Cambridge University Press, 1999).

truth—the truth that is in Jesus."[121] Finding for himself the formula that he would later recommend to others, when he was twenty years old he wrote to his father, "My error seems to be always searching for faith in place of contemplating the truths of the gospel which are such as produce faith."[122] In his 1848 application to train for the Congregational ministry at Highbury College, MacDonald confessed that he had been assailed by doubts when he was in his late teens. If he had continued down the path of skepticism, by then, he calculated, "I should have nearly if not altogether reached infidelity."[123] He went on to explain how he set himself the task of re-learning the Christian faith from scratch by studying the Bible. The result? "I have seen I trust that Jesus is my Saviour. . . . I try to do the will of my Lord and Master."[124] As an old man, he frequently reported, "My faith and hope grow stronger."[125] Doubt, he found—thanks be to God—can also be a door out of unbelief. George MacDonald, the author of *Thomas Wingfold, Curate*, was the hero of his tale, and he lived the song he sang.

[121]George MacDonald to an unknown lady, 1866, *Expression of Character*, 154.
[122]George MacDonald to his father, 8 November 1845, *Expression of Character*, 11.
[123]George MacDonald's Testimonial, 8 August 1848, *Expression of Character*, 22.
[124]George MacDonald's Testimonial, 8 August 1848, *Expression of Character*, 23.
[125]Sadler, *Expression of Character*, 292, 303.

RESPONSE

RICHARD HUGHES GIBSON

MY AIM IS TO SKETCH a few of the chief features of what I'd like to call George MacDonald's "ecumenical faith in poetry." Now, we should acknowledge at the start that to approach MacDonald's conception of "poetry" is like being confronted with an enormous mural depicting epic scenes, for poetry touches not only nearly everything in MacDonald's thought but everything in his world. What follows, then, represents a narrow, though carefully chosen, band of a much larger field.

Dr. Larsen has shown us one way into these matters by testifying to MacDonald's discernment of Christian faith within certain unsuspecting and sometimes disrespecting poets. "MacDonald's eyes of faith," he observes, "were always seeing religion in people whom others saw only as skeptics." In MacDonald's collection of "reverent doubters," Larsen notes the presence of four poets: Alfred, Lord Tennyson; Matthew Arnold; Arthur Clough; and Percy Shelley. MacDonald's ability to read between the lines of these poets' sayings and doings allowed him to use their works to illustrate profitable lessons about the practice of Christianity. In the essay "Shelley," for example, MacDonald recalls how the poet "warmly assented to a remark of Leigh Hunt, 'that a divine religion might be found

out, if charity were really made the principle of it instead of faith.'"[1] The poignancy of this moment for MacDonald lies in the fact that these two infidels have a better grasp on Paul's priorities in 1 Corinthians 13 than the faithful often do. Similarly, Larsen has explained how Tennyson's notion of "honest doubt" announced in "In Memoriam," often treated by modern scholars as a model specimen of loss-of-faith literature, in fact served the opposite end for MacDonald. In his writings, periods of Tennysonian "honest doubt" can serve as a stage along the way to a more honest, robust, and, I'd add, *generous* faith. "If there be such a thing as truth," the eponymous hero of *Thomas Wingfold, Curate* reasons at one searching moment, then "every fresh doubt is yet another finger-post pointing towards [truth's] dwelling."[2]

So, following Larsen, we may say that one use that MacDonald finds for poets is to keep us honest about doubt regarding both its actuality and potentialities. Larsen has shown us a vital theme for poetry within MacDonald's account of the life of faith. What I want to offer now is a more elemental analysis of MacDonald's treatment of poetry—not just what it might be about, but what, in a deeper sense, MacDonald believes it *is* and what, ideally, it can *do* for humanity. Larsen has helpfully prepared the way for this investigation by noting how thoroughly imbued with Romanticism was MacDonald's thinking and feeling. MacDonald sends us, to repeat Larsen's phrase, down the "Romantic road" to salvation.

[1]George MacDonald, "Shelley," in *A Dish of Orts, Chiefly Papers on the Imagination and Shakespeare* (London: Sampson, Low, Marston, and Company, 1895), 271.
[2]George MacDonald, *Thomas Wingfold, Curate*, 3 vols. (London: Hurst and Blackett, 1876), III:89.

My goal is to show that that road, or perhaps better said, "nature trail," is littered with poems; indeed, the *trail itself* is a poem written in both space and time.

DIVINE POETRY

Within what we might call MacDonald's "vocabulary of faith," poetry represents one of the most powerful and commonly used terms. He repeatedly invokes poetry as a figure to describe God's workings in his writings. Characters and readers alike are often urged to be more "poetic" in their approach to the things of God. In the remarkable essay "The Imagination, Its Function and Its Culture," MacDonald goes even farther, suggesting that poetry is better understood as a figure that we borrow from the divine life to explain our own so-called "creative" activities.[3] Only God, MacDonald observes, can be properly understood as a *poet* if we would be true to the word's Greek root, which means "maker." Only God *actually makes* anything in the sense of bringing it into being. Thus MacDonald suggests that the word *creation* be reserved for God's work alone.[4] In MacDonald's vocabulary of faith, then, poetry is a term whose first and fullest sense describes God's work—in other words, the doctrine of creation. Only after we have grasped that can we turn to the business of human poetry.

Accordingly, I will focus on this "poetic" formulation of the doctrine of creation in what follows. Yet we should recognize, even if only briefly, that poetry finagles its way into MacDonald's reflections on many other central doctrines. In the novel *The Seaboard*

[3]George MacDonald, "The Imagination, Its Function and Its Culture," in *Dish of Orts*, 4.
[4]MacDonald, "Imagination," 4.

Parish, for example, the narrator muses that while Nature is the "loveliest" of God's "books of poetry," "history" is his "grandest."[5] God is not only a natural but also a historical poet; next to his lovely nature lyrics, MacDonald can read the epic of our redemption. In his "Eighteen Sonnets About Jesus" cycle, to cite another example, MacDonald celebrates the paradoxical poetry of the incarnation. Jesus' coming, the speaker realizes in the tenth sonnet, means not only that the divine poet once walked in His poem but that he actually *became* His poem. "Poet and Poem, lo!," MacDonald writes, "one indivisible fact."[6]

What seems to attract MacDonald to the notion of "creation as poem" is not simply that Greek root, but, and equally importantly, what scholars have called the polysemic character of poetry—in other words, the fact that poems can have multiple layers of meaning. Like a poem by Shakespeare or Dante, God's cosmic poetry, MacDonald argues, is thick with "meanings" (MacDonald's phrase) and thereby capable of yielding fresh insight to those who read it again and again. In MacDonald's theological vision, creation is loaded with a superabundance of gifts: it fulfills not only our physical needs but also our cognitive ones. Creation, in short, has been composed with the whole human person in mind.

If creation is a poem, then the question of course arises about how we ought to read it. How do we extract "meanings" from it? MacDonald's answer: the imagination. Now, MacDonald has a very particular notion of what function the faculty of the

[5]George MacDonald, *The Seaboard Parish* (London: George Routledge and Sons, 1876), 141.
[6]George MacDonald, *Poems* (London: Longman, Brown, Green, et al.: 1857), 296.

imagination performs, which is quite different than modern notions. In the essay "The Imagination, Its Function and Its Culture," MacDonald defines it as follows: "The imagination is that faculty which gives form to thought—not necessarily uttered form, but form capable of being uttered in shape or in sound, or in any mode upon which the senses can lay hold."[7]

Following lessons gleaned from the writings of Coleridge, MacDonald argued that the human imagination cannot be understood properly without first recognizing God's creativity. God, MacDonald argues, has an imagination, and the activity of our imagination depends on his. This is because creation embodies God's "grand thought."[8] This whole swirling universe—including us—is at this very moment "being thought" by God.[9] Creation, in other words, is the *ongoing* expression of God's imagination.

The ages have, of course, wrestled with the question of where to locate the *imago Dei*, with proposals including reason and sociability. MacDonald plants it here, at the imagination. But whereas God's imagination is constitutive, ours is responsive. We cannot, to recall MacDonald's point about the Greek root of *poet*, call things into being through the exercise of our imaginations. The philosopher Alasdair MacIntyre has labeled humans "dependent rational animals."[10] In MacDonald's theology, we might say that we are "dependent imaginative animals." We are re-workers, or re-shapers—both notionally and physically—of what God creates.

[7]MacDonald, "Imagination," 2.
[8]MacDonald, "Wordsworth's Poetry," in *Dish of Orts*, 246.
[9]MacDonald, "Imagination," 4.
[10]Alasdair MacIntyre, *Dependent Rational Animals: Why Human Beings Need the Virtues* (Peru, IL: Open Court, 2001).

This sentiment can be found in numerous subsequent Christian theorists of the arts, including several of the Wade Center authors. What makes MacDonald distinctive is that he does not cut the human imagination, as it were, loose from the divine. We are not given materials that are simply designed for our use or play; we don't, to use Tolkien's language, "sub-create" in a vacuum. The human imagination's primary purpose, MacDonald declares, is not invention but discovery—"to inquire into what God has made."[11]

This inquiry is not designed to offer us mere reassurance that there is a God; the imagination isn't simply hunting traces of God's tinkerings. That would be to lapse into the mode of natural theology, which MacDonald's writings repeatedly condemn on the grounds that it cannot reach the most important truths about God and about nature—specifically, that Creation is an expression of God's love.[12] For MacDonald, to go into nature looking *only* for evidence that God exists asks too little of creation. Here we may return to the above point about MacDonald's attraction to the polysemic character of poetry. MacDonald regards creation as, once again, overflowing with meanings. MacDonald argues, in turn, that the human imagination uncovers these meanings that God has, as it were, laid up for our future use.

In the preface to the 1802 edition of *Lyrical Ballads*, William Wordsworth, one of MacDonald's literary heroes, had argued that

[11]MacDonald, "Imagination," 2.

[12]In "Wordsworth's Poetry" (246), MacDonald writes, "We are not satisfied that the world should be a proof and varying indication of the intellect of God. That was how Paley viewed it. He taught us to believe there is a God from the mechanism of the world. But, allowing all the argument to be quite correct, what does it prove? A mechanical God, and nothing more."

"man and nature" are "essentially adapted to each other, and the mind of man [is] naturally the mirror of the fairest and most interesting qualities of nature."[13] MacDonald agreed, but he saw further into the life of things, perceiving behind nature its Creator's forethought. In the "Imagination" essay, he writes,

For the world is—allow us the homely figure—the human being turned inside out. All that moves in the mind is symbolized in Nature. Or, to use another more philosophical, and certainly not less poetic figure, the world is a sensuous analysis of humanity, and hence an inexhaustible wardrobe for the clothing of human thought. Take any word expressive of emotion—take the word *emotion* itself—and you will find that its primary meaning is of the outer world. In the swaying of the woods, in the unrest of the "wavy plain," the imagination saw the picture of a well-known condition of the human mind; and hence the word *emotion*.[14]

Like Wordsworth, MacDonald argues that we are radically dependent on our sensory surroundings to explain our inner lives; even the word *emotion* springs from the physical world.[15] Whereas other thinkers might credit the human genius for metaphor at this moment, MacDonald here gives glory to God for creation's "formal" abundance. Metaphor, in MacDonald's scheme, becomes

[13]William Wordsworth, "Preface," in *Lyrical Ballads: 1798 and 1802* (Oxford: Oxford University Press, 2013), 106.

[14]MacDonald, "Imagination," 9.

[15]MacDonald here seizes upon a quality of language that Owen Barfield has been among the best to explain. "If we trace the meanings of a great many words . . . about as far back as etymology can take us," Barfield writes in *Poetic Diction*, "we are . . . made to realize that an overwhelming proportion, if not all, of them referred in earlier days to" either (1) "a solid, sensible object" or (2) "some animal (probably human) activity." Owen Barfield, *Poetic Diction* (Middletown, CT: Wesleyan University Press, 1984 [orig. 1928]).

a mode of remembrance and *self*-discovery; through metaphor, we think God's thoughts after Him, which, it turns out, were God's thoughts about and for us. Metaphor is a providential exercise.

Thus, in MacDonald's poetic world, we don't need to pass *through* the wardrobe to encounter God anew or to know ourselves and our neighbors rightly. We are already in the wardrobe. All around us are garments lovingly tailored to suit our inchoate thoughts. In its physical as well as semiotic dimensions, creation is profoundly—to play on MacDonald's phrase—"homely." To expect any less seems, at least from MacDonald's point of view, an affront to God's craftsmanship.

HUMAN POETRY

As an English professor, I have often heard people claim that they "don't like poetry." Within MacDonald's thought, as we have seen, this sort of statement has a blasphemous ring. Now, to be fair, the people that I am speaking about aren't complaining about God's handiwork but about *human* poetry, which is, by turns, castigated for being too flowery, too obscure, too self-indulgent. Here again, MacDonald would urge us to have a bit more faith in poetry. MacDonald frames the human poet's office not in personal but in communal terms. To be a poet, in MacDonald's world, is to be called to a form of public service.

While the imagination is a common human endowment, a poet might be said to have an especially active one. To continue with the wardrobe conceit, poets refresh old fashions, "choosing, gathering, and vitally combining" God-given "materials" as no human

had thought to do before.[16] Again, in the "Imagination" essay, MacDonald writes,

> Perceiving truth half hidden and half revealed in the slow speech and stammering tongue of men who have gone before them, they have taken up the unfinished form and completed it; they have, as it were, rescued the soul of meaning from its prison of uninformed crudity, where it sat like the Prince in the "Arabian Nights," half man, half marble.[17]

Through their discoveries and surprising ways of handling the familiar, poets renew and perfect our speech. They provide the rest of us with fresh images that enliven our hearts and minds. They give us words and pictures with which to explain ourselves. They reconnect us with a world charged with the grandeur of God.

It is notable in light of Larsen's observation that MacDonald often uses examples from the "reverent doubters" to illustrate this process. The "Imagination" essay, for instance, quotes Shelley's ode on the death of Keats, "Adonais," and Tennyson's early poem "The Princess." MacDonald makes a striking point by way of these selections, one that his Victorian readers would have more readily perceived because Shelley, Keats, and Tennyson weren't yet canonical poets. And that point is this: even poets outside the orthodox fold can offer nourishment to the faithful. MacDonald's faith in poetry is ecumenical in the full etymological sense. *Ecumenical*, let's remember, comes from the Greek and is usually taken to mean "the whole earth," or, better, "the inhabited earth."

[16]MacDonald, "Imagination," 22.
[17]MacDonald, "Imagination," 22.

Even that translation, though, loses the image sitting at its head: *oikos*, meaning "the house, the home." For MacDonald, the test of the poet's worth lies in his or her ability to draw symbols from creation of the "homely" sort discussed earlier. Through their "imaginative" responses to Creation, poets are the revelators of a sometimes-unacknowledged God.

Two Un-Conclusions

As I indicated at the start of this piece, we have only inspected a small, though I believe important, section of the vast panorama that is MacDonald's thinking about poetry. In light of that un-covered ground, I want to offer two final points that are less endings than prompts for further reflection.

The first pertains to how we understand MacDonald. In the recent past, MacDonald's fairy tales have enjoyed the lion's share of attention among his varied writings, a state of affairs that has resulted, in no small part, from his reception among the other Wade authors. With this focus on MacDonald the fantastist, I believe, has come a certain risk of forgetting that MacDonald's aim wasn't to imagine us out of this world altogether. That would be to step off, rather than proceed further down, the Romantic nature trail to salvation. MacDonald is no escapist; I briefly considered titling my response "George MacDonald, an Earthling" to emphasize this point. Through all of the literary channels he employed—fairy tales, realist fiction, sermons, poetry, essays—MacDonald sought to send his readers deeper into the heart of the world, where he had every expectation we would meet the Living God. Fairyland

represents the long way 'round (Or is it the short? Time and space are hard to measure there.)—anyway, *a* way 'round—to a right understanding of Creation and its "homeliness."

The second un-conclusion pertains to those of us who aren't just reading MacDonald out of historical interest, and it follows from the first. The "Imagination" essay is a prospectus for an ideal education. In contrast to those who take education's aim to be the attainment of a "certain repose" (which I imagine as a don reading Euclid in a wingback chair), MacDonald argues that its end should be the stirring of "a noble unrest."[18] This is the unrest of the imagination, which is, as we have seen, another way of saying, the unrest of the inquiry into the poetry of God.

MacDonald is speaking of education in the here and now of this world, of setting out on the Romantic nature trail—with a pack, he stresses, full of poetry books. Yet I cannot help detecting in this essay a still grander design: to promote "noble unrest" as the *ongoing* condition, not only of our present state but also our future one, of the companions of the Author of Beauty. Our hearts are restless until we find rest in God, Augustine teaches; to which I imagine MacDonald might reply, "But may our imaginations, following our Lord's example, never rest."

[18]MacDonald, "Imagination," 1.

GEORGE
MACDONALD
AND THE
REENCHANTMENT
OF THE WORLD

T HERE IS A MYSTICAL FIRE which is comprised
of roses, red mingled with white. It is tended
by the Lady of the Silver Moon, although you might know her
by one of her other names. The rosefire has many blessings it
can confer. It has the power to heal. Curdie, to his own surprise,
finds that his leg, which was lame, has become "perfectly sound"
when he, as it were, wakes up and smells the roses.[1] It has the
power to restore. For a whole year his majesty had been reduced
to a helpless stupor, but the fire brought him back to himself:
"He woke like a giant refreshed with wine. . . . [A] heavenly odour
of roses filled the air. . . . The king opened his eyes, and the soul

[1]George MacDonald, *The Princess and the Goblin* (New York: A. L. Burt, n.d. [orig. 1872]),
318-19.

of perfect health shone out of them."[2] It has the power to bestow spiritual gifts. Curdie, doing as he was bidden, thrusts his hands into the fire and receives for his pains the gift of discernment of spirits. Most of all, it has the power to purge, to clean, to sanctify, to make holy:

> As she spoke she set her down, and Irene saw to her dismay that the lovely dress was covered with the mud of her fall on the mountain road. But the lady stooped to the fire, and taking from it, by the stalk in her fingers, one of the burning roses, passed it once and again and a third time over the front of her dress; and when Irene looked, not a single stain was to be discovered.[3]

That, however, was but a demonstration in order that the young princess would gain spiritual understanding. And the lesson was not lost on her. Irene grasped that the greater work would be the sanctification of a person deformed by sin: "Oh, Lina! If the princess would but burn you in her fire of roses!"[4] As long as there are wounds and wickedness it is well that there should also be the rosefire of the Lady of the Silver Moon—or something like it only better.

YOUNG, RESTLESS, AND ORDAINED

In a personal mythology started by George MacDonald himself, heartily embraced by his biographer son, and repeated unceasingly in secondary sources ever since, it is claimed that he was forced

[2]George MacDonald, *The Princess and Curdie* (London: Puffin Books, 1994 [orig. 1882]), 236.
[3]MacDonald, *Princess and the Goblin*, 162-63.
[4]MacDonald, *Princess and Curdie*, 96.

out of the pastorate because his narrow-minded congregation disliked his love-infused, large-hearted theology. The real truth, which I—as a trained historian—am now able to reveal, is that George MacDonald's pastorate failed because George MacDonald was a bad pastor. Numerous Congregational ministers whose callings flourished proclaimed openly and freely the same broad-minded beliefs that the Scottish author held. MacDonald kept imagining that people would reject him when they did not. Even the markedly conservative, Calvinist congregation in Huntly, Aberdeenshire always invited him to preach when he returned to his hometown. When he came to America, he was asked to preach at Calvinist Princeton even though the MacDonalds thought of it as "the hot bed of the old Theology."[5] After he parted ways with the congregation at Arundel, MacDonald moved to Manchester, where he was immediately invited to preach in the largest Congregational church in that great metropolis by its pastor, Robert Halley, a leading light of the denomination. As for the world's leading city, the most popular Congregational preacher in London was Thomas Binney, a former chairman of the Congregational Union of England and Wales; he was one of MacDonald's references. No, it is simply inaccurate to imagine that the young Scotsman was hounded and excluded for his beliefs.

Quite the opposite, I have come to suspect that MacDonald might even have been unconsciously sabotaging his own ministry. His real dream was to be a poet. Even when he was training for

[5]Greville MacDonald, *George MacDonald and His Wife* (London: George Allen & Unwin, 1924), 441.

the ministry, he neglected his divinity studies for his literary pursuits. Nevertheless, he was also determined to marry and badly needed an income, and there were no salaried positions to be had for entry-level poets. The pressure of adult responsibilities bore down on the dreamy young man. One suspects that like Anodos, MacDonald wished that on his twenty-first birthday he could have been whisked away to Fairy Land. Even before he was ordained, he was already scheming that perhaps he would only have to stick at the ministry for six years or so before he could leave it and "write a poem for the good of my generation."[6] One of the recurring motifs in MacDonald's novels is that of a Christian minister who has callously chosen his holy vocation just as a way to earn money. This charge is often made with alarming vehemence. In *Wilfrid Cumbermede*, we are told emphatically that entering "the Church for a living" is "worse than being an infidel."[7] In *Adela Cathcart* such a person is declared to be like some disreputable figure of old, making money by selling indulgences.[8] In *Thomas Wingfold, Curate*, such a person is pronounced to be guilty of the sin of simony.[9] None of those snippets, however, allows one to grasp just how much MacDonald bangs on and on about this, sometimes even returning to reiterate the same point for a different character within the same novel. In short, it seems clear to me that these emotive comments arose from self-loathing, from

[6]William Raeper, *George MacDonald* (Batavia, IL: Lion, 1987), 80.

[7]George MacDonald, *Wilfrid Cumbermede: An Autobiographical Story*, new edition (London: Kegan Paul, Trench, Trübner & Co., n.d. [orig. 1872]), 244. See also 194.

[8]George MacDonald, *Adela Cathcart* (London: Sampson Low, Marston and Company, n.d. [orig. 1864]), 15.

[9]George MacDonald, *Thomas Wingfold, Curate* (New York: George Routledge and Sons, n.d. [orig. 1876]), 199.

MacDonald's own sense of shame that he had accepted a pastorate not because he knew that he was called to it as his life's work but as an expedient way to gain an income. The clearest act of self-sabotage was his growing a beard, which was generally considered to be an unprofessional look for a Christian minister. MacDonald did not even pretend that some kind of principle was at stake in this matter. In other words, far from doing all he could to be accepted as a pastor, he was trying to ensure that people literally could not even see him as one. What really sunk his pastorate, however, were more substantial issues related to character flaws that he possessed in his youth and early adulthood. Not to put too fine a point on it, the young George MacDonald could be smug, self-righteous, vain, proud, disdainful, dismissive, and arrogant. When he was studying at both Aberdeen and Highbury College, he held aloof from his fellow students, generally despising them for what he perceived to be their mindless mediocrity. When he became a tutor, he deeply resented being the servant of people whom he thought of as his inferiors in terms of personal abilities. MacDonald sabotaged his own ministry by looking down on the people he was meant to serve. He even mocked the working-class accent of a member of his congregation and would mimic his public prayers.[10] He haughtily assumed that those in trade or business were worldly, greedy, vulgar, and dishonest, and therefore he did not respect his deacons. When the chapel at Huntly graciously still invited him to preach despite his broad views and his beard, MacDonald noticed that the general

[10]Greville MacDonald, *George MacDonald and His Wife*, 181.

standard of living had risen since his childhood and therefore decided that he would use his sermon to denounce them for their presumed love of money.[11] His own congregation's original complaint—as was often the case when he was a guest preacher as well—was not that they disagreed with his sermons, but that they could not understand them. He responded, as he always had, that he had "no desire to be understood" by such a dull and lazy lot.[12] And he even had the chutzpah to claim that they were the ones who were unteachable. Those who loved MacDonald and most believed in his ministry were the ones who could see most clearly that such a want of sympathy for his congregation would doom his pastorate. Once MacDonald lost his position at Arundel, his father was alarmed to learn that his son did not even plan to attend the annual meeting of the Congregational Union, a gathering of pastors in his denomination from across the nation and therefore the prime opportunity for facilitating a call to a new congregation. In reply, MacDonald expressed his "contempt" and disclaimed any liking "for their public assemblies," haughtily echoing the Almighty's hatred of certain religious assemblies expressed by the prophets Isaiah and Amos.[13] Did I mention that he could be arrogant? Even in midlife, MacDonald could sound insufferably smug when denouncing smugness, and unbearably self-righteousness when railing against self-righteousness. In his application for theological training, the young Scot had written candidly and truly, "I know that much

[11]George MacDonald to his wife, 28 July 1855, *An Expression of Character: The Letters of George MacDonald*, ed. Glenn Edward Sadler (Grand Rapids: Eerdmans, 1994), 98.

[12]George MacDonald to his father, 23 February 1850, *Expression of Character*, 32.

[13]George MacDonald to his father, 16 November 1853, *Expression of Character*, 68. See Is 1:13 and Amos 5:21.

that is evil mingles with my motives for desiring the ministry— ambition and perhaps more of vanity intrude."[14] When he was in his early twenties and still deciding on whether or not to pursue the ministry, he had written to his father, "But on the other hand I fear myself. I have so much vanity—so much pride."[15] I am arguing that MacDonald needed to stick that hand into the rosefire.

A GREAT GOOD IS COMING

The mature George MacDonald thought of himself as someone who had rejected Calvinism, and this is often emphasized in secondary sources, but it is important to grasp what precisely is and is not meant by this. What he viscerally rejected was the doctrine of double predestination. Reading him today, however, one of the most striking features of his theology is its robust, prominent, and unflinching belief in divine providence. As the clergyman says in *Annals of a Quiet Neighbourhood*, "People talk about special providences. I believe in the providences, but not in the specialty.... It would be gloriously better if they could believe that the whole matter is one grand providence."[16] In his own voice, MacDonald could assert this most forcefully as an indispensable fundamental of the faith: "Either not a sparrow falls to the ground without Him, or there is no God."[17] This conviction was always permeating his thoughts. Even such a banal event as going to visit someone without an appointment and finding

[14]George MacDonald's testimonial, 8 August 1848, *Expression of Character*, 23-24.
[15]George MacDonald to his father, 11 April 1847, *Expression of Character*, 17.
[16]George MacDonald, *Annals of a Quiet Neighbourhood* (New York: George Routledge and Sons, 1869 [orig. 1867]), 16.
[17]George MacDonald, *The Miracles of Our Lord* (New York: George Routledge and Sons, n.d. [orig. 1870]), 34.

that he was not at home caused MacDonald to reflect that there must be a purpose behind it as "the smallest events are ordered for us."[18]

A thoroughgoing belief in divine providence can be a comforting doctrine because it provides a grounding for the hope that, in the end, all shall be well. Adam informs Lilith that her plans for evil will inevitably be thwarted because good has been destined to triumph.[19] Illustrating a biblical truth, the goblins "had been caught in their own snare; instead of the mine they had flooded their own country, whence they were now swept up drowned."[20] And then there is this meditation on this same theme in "Little Daylight":

> Now wicked fairies will not be bound by the laws which the good fairies obey, and this always seems to give the bad the advantage over the good, for they use means to gain their ends which the others will not. But it is all of no consequence, for what they do never succeeds; nay, in the end it brings about the very thing they are trying to prevent. So you see that somehow, for all their cleverness, wicked fairies are dreadfully stupid, for although from the beginning of the world they have really helped instead of thwarting the good fairies, not one of them is a bit the wiser for it. She will try the bad thing just as they all did before her; and succeed no better of course.[21]

While a warning to the wicked, this truth is a consolation and encouragement to those who seek to do what is right. Thus

[18]George MacDonald to his uncle, 22 May 1847, *Expression of Character*, 20.

[19]George MacDonald, *The Visionary Novels of George MacDonald*, ed. Anne Fremantle (New York: Noonday Press, 1954), 154. *Lilith* was first published in 1895.

[20]MacDonald, *Princess and the Goblin*, 340.

[21]George MacDonald, *The Gifts of the Child Christ, Fairytales and Stories for the Childlike*, ed. Glenn Edward Sadler, 2 vols. (London: A. R. Mowbray & Co., 1973 [orig. 1882]), I:147.

Phantastes ends triumphantly with Anodos gradually discerning what the rustling leaves are saying:

> "A great good is coming—is coming—is coming to thee, Anodos"; and so over and over again.
>
> . . . Yet I know that good is coming to me—that good is always coming; though few have at all times the simplicity and the courage to believe it. What we call evil is the only and best shape, which, for the person and his condition at the time, could be assumed by the best good.[22]

That last line leads on to the more unflinching side of this same truth, namely, that all of the evil, trouble, and suffering we experience should be accepted as actively willed by Almighty God. For MacDonald, there was no *reductio ad absurdum* to this doctrine, as Christina learns when she is being catechized by Ian:

> "Then you must thank God for everything—thank him if you are drowned, or burnt, or anything!"
>
> "Now you understand me! That is precisely what I mean."[23]

It would be a great mistake to confuse for Victorian sentimentality what is actually the thunderous voice of John Knox echoing off the Scottish hills:

> "Margaret, dear, I begin to like my lameness, I think."
>
> "Why, dear?"
>
> "Why, just because God made it, and bade me to bear it."[24]

[22]MacDonald, *Visionary Novels*, 434. *Phantastes* was first published in 1858.

[23]George MacDonald, *What's Mine's Mine* (London: Kegan Paul, n.d. [orig. 1886]), 234.

[24]George MacDonald, *David Elginbrod* (London: Hurst and Blackett, n.d. [orig. 1863]), 398.

We are told of Diamond's dodgy surroundings, "Some people may think it was not the best place in the world for him to be brought up in; but it must have been, for there he was."[25] And although people call North Wind all kinds of dreadful names—Bad Fortune, Evil Chance, Ruin, and the like—these are just ways of misunderstanding or railing against Providence: Diamond discerns truly that she is good even when she is inflicting loss, suffering, and death.[26] All such evils have the potential to be agents in our sanctification: "People must have troubles, else would they grow unendurable for pride and insolence."[27] In his earthly ministry, Jesus did not cure all the sick in Judea because for many of them their "illness had not yet wrought its work."[28] In his will is our peace.

MacDonald held fast to this insight in his own personal life. He cherished his wife dearly, yet this was his way to comfort her when she was in pain: "My darling, I shall love you more than ever. I can hardly be sorry for your sufferings, if they made you hear one word from Him."[29] And, to his great credit, what was good for the goose was also good for the gander. MacDonald's own health problems were painful and unpleasant, including spitting up blood, yet he would report, "The messenger of Satan has got me by the lungs again, dearest sister, and thrown me into bed, where I trust God will have his will with my heart, and

[25]George MacDonald, *At the Back of the North Wind* (London: J. M. Dent & Sons, 1959 [orig. 1871]), 139.
[26]MacDonald, *North Wind*, 313.
[27]MacDonald, *Thomas Wingfold*, 293.
[28]MacDonald, *Miracles*, 42.
[29]George MacDonald to his wife, 17 August 1865, *Expression of Character*, 146.

then my lungs may go to dust for what I care."[30] Or more generally, "I for my part would not go without one of my troubles. I have needed every one."[31] MacDonald had an extraordinary, unwavering commitment to submitting to the will of God. In the voluminous records that remain—however bitter an experience or circumstance might be—he never complains or protests against what providence has wrought in his life. The closest I know of to any such minority report are these beautiful lines from *Within and Without*:

Father, I am thy *child*,
Forgive me this:
Thy poetry is very hard to read.[32]

Even while his daughter Mary was slowly dying, MacDonald claimed to discern that it was elevating her spiritually and that his son (her brother) Greville was also benefiting from watching her be purified through suffering. A man of sorrows and acquainted with grief, George MacDonald was forced to endure the deaths of four of his children, of his wife, and even of a granddaughter. In *Diary of an Old Soul* he addresses his lost bairns poignantly:

I love you, my sweet children, who are gone
Into another mansion . . .
I love you, sweet dead children.[33]

[30]George MacDonald to Georgia Cowper-Temple, 5 October 1877, *Expression of Character*, 256.

[31]George MacDonald to his father, 2 December 1857, *Expression of Character*, 124.

[32]George MacDonald, *Within and Without* (New York: Scribner, Armstrong & Co., 1872 [orig. 1855]), 174.

[33]George MacDonald, *The Diary of an Old Soul* (London: George Allen & Uwin, 1922 [orig. 1880]), 39.

When MacDonald wrote to a friend who had recently lost her husband, expounding upon the text, "Blessed are they that mourn," he did not lack the moral authority to do so.[34] One of his favorite verses from the Hebrew Scriptures was Job 13:15: "Though he slay me, yet will I trust in him." And MacDonald would earnestly declare along with the Psalmist, "It is good for me that I have been afflicted; that I might learn thy statutes" (Ps 119:71).[35] To face life aright, one must accept that it is *all* one grand providence: "It is not the high summer alone that is God's. The winter also is His. . . . And all man's winters are His."[36]

THE FLESH AND THE SPIRIT

MacDonald so believed that all suffering was sent by God for a reason that he developed the eccentric and dubious assumption that every illness was a manifestation of a spiritual problem. The extreme opposite view, of course, is philosophical materialism, which he satirized in the diagnosis of Hum-Drum in "The Light Princess":

> My rooted and insubvertible conviction is, that the causes of the anomalies evident in the princess's condition are strictly and solely physical. But that is only tantamount to acknowledging that they exist.[37]

[34]George MacDonald to Georgia Cowper-Temple, 9 December 1888, *Expression of Character*, 339.

[35]George MacDonald to Susan Scott, 1 June 1894, *Expression of Character*, 361. For a use of this text in his creative writing, see MacDonald, *North Wind*, 215.

[36]MacDonald, *Adela Cathcart*, 19.

[37]George MacDonald, *The Light Princess and Other Fairy Stories* (London: Blackie and Son, n.d.), 35.

Contrariwise, in a letter to his wife, MacDonald asserted that "all our ailments" are "mental."[38] He makes a similar reflection in a work of fiction: "My assurance is, that, near or far off, in ourselves, or in our ancestors—say Adam and Eve, for comprehension's sake—all our ailments have a moral cause."[39] In MacDonald's novels, it is a very common plot point for a physical illness to be discerned to have a spiritual cause—this motif arguably becoming, especially in its cumulative effect, unintentionally comical. In *Thomas Wingfold, Curate*, Leopold is dying of a bad conscience.[40] In *Annals of a Quiet Neighbourhood*, even the local physician, Dr. Duncan, diagnoses that Catherine Weir is "dying of resentment."[41] As for Harry in *David Elginbrod*, we are informed that "the boy had been dying for lack of sympathy."[42] And Adela Cathcart, poor, delicate soul, was "dying of ennui," but—spoiler alert—mercifully, in the end, she was not bored to death.[43] Sometimes such problems took on epidemic proportions. MacDonald claimed that swaths of women were dropping off because of bad theology: "The theological nourishment which is offered them is generally no better than husks. They cannot live upon it, and so die and go home to their Father."[44]

The corollary to this was that spiritual actions could be used to treat physical conditions. When their daughter was ill, MacDonald wrote to Louisa,

[38]George MacDonald to his wife, 26 September 1853, *Expression of Character*, 65.

[39]MacDonald, *Adela Cathcart*, 74.

[40]MacDonald, *Thomas Wingfold*, 342-47. This is Chapter LV: "A Haunted Soul."

[41]MacDonald, *Annals*, 338.

[42]George MacDonald, *David Elginbrod* (London: Hurst and Blackett, n.d. [orig. 1863]), 138.

[43]MacDonald, *Adela Cathcart*, 316.

[44]MacDonald, *Adela Cathcart*, 59.

I cannot help thinking if Lily would give herself up quite to him to whom she belongs, she would be at peace and then perhaps grow better ... I do think Lily will be much better when she consciously gives in to the will of God.[45]

Such recommendations are also sprinkled throughout MacDonald's published writings. He observed that modern science had been very clever at showing how mental illness was a "physical disorder" and yet, nonetheless, he recommended "the spiritual cure of faith in the Son of Man, the Great Healer."[46] Adela Cathcart is prescribed a daily dose of fairy tales. And our students, in particular, might wish to know that MacDonald advises as an antidote for a broken heart the doctrine of the incarnation: "There is but one cure: the fellow-feeling of the human God, which converts the agony itself into the creative fire of a higher life."[47]

While this chapter is primarily structured so as to approach this theme in more refracted ways, we have reached the point where we should take a brief moment to say it directly: George MacDonald was a prophet of holiness who put sanctification at the center of his Christian teaching. Already at the age of sixteen he was emphasizing this: "I hope to serve God & to be delivered not only from the punishment of sin, but also from its power."[48] And again in his application to Highbury College, "I wish to be delivered from myself. I wish to be made holy. My hope is in God."[49] He warned that there is no static state in which one can

[45]Raeper, *George MacDonald*, 361.
[46]MacDonald, *David Elginbrod*, 367.
[47]MacDonald, *David Elginbrod*, 259.
[48]George MacDonald to his father, 5 January 1841, *Expression of Character*, 8.
[49]George MacDonald's Testimonial, 8 August 1848, *Expression of Character*, 23.

just complacently rest content in having been saved and forgiven: "And so all growth that is not towards God / Is growing to decay."[50] Sanctification is the great business of life: "We are in this world in order to become pure."[51] And the great drama of life is whether or not we will repent, turn from our sinful ways, and become obedient to the will of God:

"If you're after any mischief, she'll make you repent it."

"The best thing that could happen under the circumstances," said the Prince.

"What do you mean by that?" said the cook.

"Why, it stands to reason," answered the Prince, "that if you wish to do anything wrong, the best thing for you is to be made to repent of it."[52]

Some of the most exciting scenes in MacDonald's novels revolve around whether or not someone will give in to temptation or pursue the way of holiness irrespective of the personal cost. One of my favorites comes in *Annals of a Quiet Neighbourhood*. The clergyman is trying to persuade Catherine Weir, for the good of her soul, to leave vengeance to the Lord. In the course of this godly endeavor, he discovers that her contemplated act of revenge would remove a man who is not only his rival, but a wicked and dangerous influence, away from the woman he loves most in all the world. It would be so easy to just let Weir carry on with her plan. The true quest of the Christian knight is not for the Holy Grail but for Holiness itself.

[50]MacDonald, *Within and Without*, 25.
[51]MacDonald, *Annals*, 4.
[52]MacDonald, *Gifts of the Child Christ*, I:143.

Blessed Are the Dead

In Christian theology, sanctification, whatever else it might be, is an eschatological hope. Therefore, not unrelatedly, George Mac-Donald was also a great prophet of the afterlife. His earliest childhood memory was of a funeral, and MacDonald was invariably a reassuring presence in the face of death. During their engagement, Louisa's mother died, and MacDonald's radiant faith was a comfort to her whole family: "Death is not an end—but a fresh beginning, the grandest birthday of all, the getting out of the lobby, into the theatre."[53] Even when his own children died, he never wavered in that conviction. He would speak of death as a blessing. Mossy tastes death and thereby learns that "it is only more life."[54] And this was MacDonald's idea of a love letter to his betrothed: "Oh, Louisa, is it not true that our life here is a growing unto life, and our death is being born—our true birth?"[55] MacDonald insisted that Jesus taught his followers that death is like sleep and that they will awake from it to newness of life.

George MacDonald was fond of speculating about the afterlife, and some of these theories were devised in conscious defiance of the standard teaching in the kind of churches in which he had been raised and ordained. Always honoring the words of our Lord, he accepted that there were no marriages in the age to come. Nevertheless, he liked to think that if people truly loved each other on earth they would still have some kind of special bond hereafter. After all, did not the apostle Paul teach that the gifts of God are

[53]Raeper, *George MacDonald*, 75.
[54]MacDonald, *Light Princess*, 187.
[55]George MacDonald to Louisa Powell, 23 October 1848, *Expression of Character*, 26.

without repentance (Rom 11:29)?[56] MacDonald also could not but hope that there might be an afterlife for the lower animals as well. His "dear old mare" in Huntly, in particular, he wished to try to get past the celestial post.[57] In *What's Mine's Mine*, Ian harbors a similar hope for his dearly departed dog.[58] In his most expansive mood, MacDonald could fancy that there was a sense in which even a flower had a soul.[59]

Then there was his attraction to something like a doctrine of purgatory. While many Protestants seem reticent to grasp this, it seems to me that something akin to an event of purgation is a theological necessity. Without holiness no one shall see the Lord (Heb 12:14). If they really think about it, it does not seem to me that most Protestants seriously believe that God is willing to compromise with sin and allow it into his heaven. We will *not* still be contaminated with lust, greed, envy, and pride in the life eternal, and therefore it must have been eradicated, purged out of us, before we entered into paradise. Nevertheless, I have referred to this reality as an event of purgation rather than as purgatory. What Protestants have disliked—at least in part—about the concept of purgatory are the connotations that it is a place and that those who are in it are enduring the elapsing of expanses of time. Mac-Donald did not think in terms of there being any such place—as we shall see, he thought of God himself as the fire—but he was quite willing to think in terms of the experience of purgation

[56]MacDonald, *What's Mine's Mine*, 276.
[57]George MacDonald to his wife, 10 July 1855, *Expression of Character*, 92.
[58]MacDonald, *What's Mine's Mine*, 74.
[59]MacDonald, *What's Mine's Mine*, 244.

taking place in the afterlife over long stretches of time. God is quite willing to expend time. For him, a thousand years is as a day. The Lord is not slow as some count slowness, but he is patient. At the very least, one can see MacDonald's view as a kind of heuristic devise for grasping that God would rather take his time and do it right than leave one of his children only partially freed from sin. The truth that really needs to sink into our stubborn, sinful consciousness is that without holiness no one will see the Lord. If it takes aeons, so be it: "Is there not the might of love, and all eternity for it to work in, to set things right?"[60] MacDonald often referred to Dante, even sneaking him into *At the Back of the North Wind* under a pseudonym.[61] As with reading the *Purgatorio*, so it is the same, in my view, with reading George MacDonald: what the writer really wants you to grasp from these fantasized futures—and something that we are surely still able to grasp even if we must part ways with aspects of these theological visions as erroneous—is the necessity of pursuing holiness and sanctification in this life that we are living right now on earth.

God loves you so much that he is willing to inflict pain upon you in order to free you from your sin. What people think of as purgatorial fires are just what it means to encounter the Almighty, for our God is a consuming fire (Heb 12:29).[62] It is true that God is Love, but it is also true that love hurts. As we read in *Within and Without*, "Yes, darling; love does hurt. It is too good / Never

[60]MacDonald, *Thomas Wingfold*, 399.

[61]As the Italian Durante. MacDonald, *North Wind*, 94-6.

[62]George MacDonald, "The Consuming Fire," in *Unspoken Sermons: Series I, II, and III* (Whitethorn, CA: 2004 [orig. 1867, 1885, and 1889]), 18-33.

to hurt. / . . . O the hurt, the hurt, the hurt of love!"[63] The fear of the Lord means that we are to know God's "love with its purifying fire."[64] It was because Jesus loved the rich young ruler that he told him to give away all his possessions. Alas, this man thought more of the initial pain than of the resulting perfection. There is no way to prevent it from hurting. Curdie must stick his hands into the rosefire: "It will hurt you terribly, Curdie, but that will be all; no real hurt but much good will come to you from it."[65] As I used to tell my children when they were afraid of getting shots at the doctor's office, "It will only hurt until the pain stops." Yet the right thing to do is to submit to God's will:

> But thou are making me, I thank thee, sire.
> What thou hast done and doest thou know'st well,
> And I will help thee:—gently in thy fire
> I will lie burning; on thy potter's-wheel
> I will whirl patient, though my brain should reel:
> Thy grace shall be enough the grief to quell,
> And growing strength perfect through weakness dire.[66]

The great error is imagining that you are going to find some way to hold on to your sin permanently. MacDonald is known for questioning the traditional doctrine of eternal punishment but, once again, it is a mistake to imagine that he opted for some kind of sentimental, fluffy view. His teaching on hell is, in a way, arguably more uncompromising than that of many traditionalists.

[63]MacDonald, *Within and Without*, 193.
[64]MacDonald, *Unspoken Sermons*, 317.
[65]MacDonald, *Princess and Curdie*, 69.
[66]MacDonald, *Diary of an Old Soul*, 131.

MacDonald insisted that even in hell someone will still not be allowed to hold on to their sin:

> "Father," repeated Robert, "you've got to repent; and God won't let you off; and you needn't think it. You'll have to repent some day . . . either on earth or in hell. Would it not be better on earth? . . . [In hell] the torturing spirit of God in them will keep their consciences awake, not to remind them of what they ought to have done, but to tell them what they *must* do now . . . tell them that there is *no* refuge from the compelling Love of God, save that Love itself—that He is in hell too, and that if they make their bed in hell they shall not escape him, and then, perhaps, they will have some true presentiment of the worm that dieth not and the fire that is not quenched."[67]

The point of MacDonald's recurring emphasis on the story of the rich young ruler is the very Protestant one that there are no "counsels of perfection" that ordinary Christians are free to ignore: Jesus commands every single one of his disciples to be perfect even as their Father in heaven is perfect (Mt 5:48). In the end, God will not be satisfied with anything less than complete sanctification: "Escape is hopeless. For Love is inexorable. Our God is a consuming fire. He shall not come out till he has paid the uttermost farthing."[68] There might be a more theologically careful or accurate way to make that point, but it will not be more accurate unless it too includes the complete eradication of sin from the lives of the redeemed in the age to come.

[67]George MacDonald, *Robert Falconer* (London: Hurst and Blackett, n.d. [orig. 1868]), 406-07.
[68]MacDonald, *Unspoken Sermons*, 31.

The goblin fairies taunt Anodos by chanting, "Look at him! Look at him! He has begun a story without a beginning, and it will never have any end."[69] MacDonald did not make that mistake. His theological vision was firmly located in a narrative with a beginning, middle, and end: the story of Creation, Fall, Redemption, and Restoration. His approach in this regard was deeply Augustinian. As we have stressed MacDonald's belief in the providential uses of suffering, it is important to observe also that this was relativized in his thought by a prelapsarian perspective: "And first I would remind them that all suffering is against the ideal order of things. . . . God dislikes it. He is then on our side in the matter."[70] With Augustine, MacDonald always insisted that evil was just depravation of the good: "God is life essential, eternal, and death cannot live in his sight; for death is corruption, and has no existence in itself, living only in the decay of the things of life."[71] In *Lilith* we read, "Evil was only through good. Selfishness but a parasite on the tree of life."[72] Lilith's evil was "what God could not have created."[73] MacDonald believed in the doctrine of original sin, reflecting humbly, "They tell me I was born in sin, and I know it to be true."[74] Elsewhere he wrote this on the redemption that is the antidote to the Fall: "I believe in the degraded and worthless condition of man as regards that which is good and holy—I believe in the perfect and full atonement of Jesus Christ."[75] MacDonald

[69]MacDonald, *Visionary Novels*, 281.

[70]MacDonald, *Miracles*, 27-28.

[71]MacDonald, *Unspoken Sermons*, 319.

[72]MacDonald, *Visionary Novels*, 85. *Lilith* was first published in 1895.

[73]MacDonald, *Visionary Novels*, 213.

[74]MacDonald, *Unspoken Sermons*, 542.

[75]George MacDonald's testimonial, 8 August 1848, *Expression of Character*, 24.

would recapitulate the narrative of the Fall of Adam and Eve in ways reminiscent of Augustine's account of stealing the pears. In *Wilfrid Cumbermede*, our schoolboy protagonist becomes lost on an outing and ends up needing to walk across some private land to make his way back. An apple literally falls at his feet but, having reached the age of accountability, he knows that he has no right to it. Still, young Wilfrid gives in to temptation: "The moment I saw the wound my teeth had made, I knew what I had done, and my heart died within me. . . . I, poor miserable sinner . . . let no one laugh at me because my sin was small: it was enough for me."[76] In *Lilith*, in a parallel to the Tree of Life versus the Tree of Knowledge of Good and Evil, there is good fruit, but there is also a certain kind of apple that one becomes bad by choosing to eat.[77] The perspective of Eden and of the Eschaton strengthens one in this age to work for the coming of the Kingdom of God. As Diamond reflects, "This will never do. I can't give in to this. I've been to the back of the north wind. Things go right there, and so I must try to get things to go right here. I've got to fight the miserable things."[78] Lilith is promised that—although forsaking her evil ways will be painful—the end result will be to restore her to the true person she was meant to be.[79] MacDonald was a master of the modern fairy tale. Frederick Buechner, in *Telling the Truth: The Gospel as Tragedy, Comedy, and Fairy Tale*, reminds us that fairy tales are inherently eschatological because they end with a

[76]MacDonald, *Wilfrid Cumbermede*, 62-63.
[77]MacDonald, *Visionary Novels*, 66.
[78]MacDonald, *North Wind*, 125.
[79]MacDonald, *Visionary Novels*, 208.

happily-ever-after in which the protagonists have been "transformed into what they have it in them at their best to be."[80]

The Freedom of the Rose Tree

George MacDonald loved roses. Although I will leave it to some more industrious soul to attempt to prove it conclusively, I have a theory that he never wrote a book-length work of literature—whether poetry, fantasy, fairy tale, or realist novel—in which he failed to mention them. They grow in the most unlikely of places, including even a discourse on Job in the *Unspoken Sermons*.[81] The earliest surviving poem of his, written when he was just seventeen years old, contained a rose.[82] In *David Elginbrod*, Hugh tells a story in which a seed fantasizes, "I mean to be a rose. There is nothing like a splendid rose. Everybody will love me then!"[83] Moreover, MacDonald had such a high regard for roses that he seemed to think it unbecoming to speak of them irreverently as growing on bushes. MacDonald's roses, more often than not, grow on trees. There are rose trees in *Robert Falconer* and in *What's Mine's Mine*.[84] In *Wilfrid Cumbermede* we have the pleasure of glimpsing "a little white rose tree, half mingled with the moonlight."[85] In *Phantastes* we even meet the "the fairy of the rose-tree," which, I suppose, clinches the argument that they do not grow only on bushes, because if there is no such thing as a rose tree then it

[80]Frederick Buechner, *Telling the Truth: The Gospel as Tragedy, Comedy, and Fairy Tale* (San Francisco: Harper & Row, 1977), 80.

[81]MacDonald, *Unspoken Sermons*, 360.

[82]Raeper, *George MacDonald*, 112.

[83]George MacDonald, *David Elginbrod*, 111.

[84]MacDonald, *Robert Falconer*, 402; MacDonald, *What's Mine's Mine*, 45.

[85]MacDonald, *Wilfrid Cumbermede*, 175.

stands to reason there could not be a rose-tree fairy.[86] MacDonald held to this vision in his personal life as well. When he was courting Louisa, he promised in his ardor that he would send her a rose from "a little tree" he knew of, although the word "little" might have been intended to concede that less romantic eyes might have mistaken it for a bush.[87] In *Thomas Wingfold, Curate*, MacDonald made an attempt to let this special vegetation grow into an aphorism: "A crooked rose-tree may yet bear a good rose."[88] This quest came to glorious fruition in *Donal Grant*: "The rose is the freedom of the rose tree."[89] That is Augustinian theology refined into poetry. True human freedom is to be found only in purity, in holiness, in obedience to the will of the Father, in becoming what God Almighty intended us to be: the rose is the freedom of the rose tree.

It is not at all surprising that MacDonald liked to reference roses in his writings. They evoke so well so much that was important to him: to begin with the earthy, both reverence for Nature and the delights of romantic love. This particular flower, it is also hardly surprising to add, also had spiritual import for him. There is a long tradition of the mystical rose in Western spirituality. Gothic cathedrals often gave pride of place to a magnificent rose window. There are Marian associations with this image, but they are far from the only ones. Indeed, Jesus himself is the Rose of Sharon. To evoke the subject matter of the first chapter once again,

[86]MacDonald, *Visionary Novels*, 278.
[87]George MacDonald to Louisa Powell, 15 May 1849, *Expression of Character*, 28.
[88]MacDonald, *Thomas Wingfold*, 268.
[89]George MacDonald, *Donal Grant* (London: Kegan Paul, Trench, Trübner & Co., n.d. [orig. 1883]), 293.

this particular Christological image is even the theme of a Christmas carol, "Lo, How a Rose E'er Blooming." Furthermore, Dante beholds the saints in Paradise in the form of a celestial rose. MacDonald referred to that "white rose of the redeemed" in *Lilith*, and as a prophet of the afterlife it seems that this symbolic connotation from *The Divine Comedy* was an especially resonant one for him.[90]

ALL MIRRORS ARE MAGIC MIRRORS

And so we return to the rosefire. There might even have been an autobiographical prompt for this literary image. One of MacDonald's sons picked some flowers as a present for his mother. When the boy misbehaved, the bearded patriarch punished him by throwing them into the fire.[91] Such an upsetting incident no doubt made a lasting impression. There an agitated George MacDonald stood, watching roses burning in the grate while listening to his son crying. God is our Father. God is Love. And love hurts. Our God is consuming fire. MacDonald could speak of "that form of divine love which appears as a consuming fire."[92] Roses are a quintessential symbol of love. Winston Churchill accepted the hint given in Psalm 22:6 that we should think of ourselves as worms, but found a grace note within it: "We are all worms," the statesman conceded, "but I do believe that I am a glowworm."[93] My friends, it is a fire, but I do believe that it's a rosefire. Sanctification is a

[90]MacDonald, *Visionary Novels*, 31. *Lilith* was first published in 1895.
[91]Raeper, *George MacDonald*, 267.
[92]MacDonald, *Adela Cathcart*, 147.
[93]David Reagles and Timothy Larsen, "Winston Churchill and Almighty God," *Historically Speaking*, XIV, 5 (November 2013): 8-10; Violet Bonham Carter, *Winston Churchill: An Intimate Portrait* (New York: Harcourt, Brace & World, 1965), 4.

painful process, but there is a sweet scent of flowers in the air to reassure us that it is benign and beneficial: "It will hurt you terribly, Curdie, but that will be all; no real hurt but much good will come to you from it."[94]

In 1894, George MacDonald remarked in a letter, "Next month I shall be 70, and I am humbler by a good deal than when I was 20."[95] This testimony is true. I have taken MacDonald at his word when he wrote at the age of twenty-two, "I have so much vanity—so much pride," and I now take him at his word from the other side of the hill of life. And the reason why this late progress report is true is that, by God's grace, so was his early determination, from which he did not depart: "I hope to serve God & to be delivered not only from the punishment of sin, but also from its power. . . . I wish to be delivered from myself. I wish to be made holy. My hope is in God." As the decades came and went, he experienced much loss and hardship and accepted it all as ordered by Providence. Old age has its own, special sufferings which must be borne. MacDonald warned in one of his *Unspoken Sermons*, "When young we must not mind what the world calls failure; as we grow old, we must not be vexed that we cannot remember, must not regret that we cannot do, must not be miserable because we grow weak or ill."[96] By 1897, aged seventy-two, the venerable Scottish author was being harried continually by physical pain and difficulty sleeping. Then he had a stroke. His mind became increasingly unreliable: "We must not

[94]MacDonald, *Princess and Curdie*, 69.
[95]George MacDonald to J. S. Blackie, 11 November 1894, *Expression of Character*, 362-63.
[96]MacDonald, *Unspoken Sermons*, 369.

be vexed that we cannot remember." He slipped into a silent world all his own, eventually losing the power of speech altogether. When his wife Louisa died, his children were not sure that he would even be able to comprehend what they were telling him, but the mute, old man began to weep uncontrollably.[97] Before blessed death finally came for him, MacDonald lived on in this silenced, clouded, degraded, and completely dependent condition for another three and half years. Those who do not believe in divine providence no doubt would claim that it would have been better if he had died earlier. MacDonald himself however—back when he could still communicate—had expressed the conviction that he could not afford to go without any of his troubles, that he needed every one. After a long obedience in the same direction, MacDonald had finally reached, to evoke the last lines of T. S. Eliot's *Four Quartets*:

A condition of complete simplicity
(Costing not less than everything)
And all shall be well and
All manner of things shall be well
When the tongues of flame are in-folded
Into the crowned knot of fire
And the fire and the rose are one.[98]

Across the long life of George MacDonald, I, for one, think I can discern a process of sanctification, a steadily intensifying, sweet fragrance of Christ, the Rose of Sharon.

[97]Greville MacDonald, *George MacDonald and His Wife*, 561.
[98]T. S. Eliot, *Collected Poems, 1909–1962* (San Diego: Harcourt Brace Jovanovich, 1970), 209 ("Little Gidding," V:253-259).

Many Victorians felt oppressed by Enlightenment rationalism, philosophical materialism, scientific dissection, procrustean logic, Utilitarianism, mechanization, rationalization, urbanization, industrialization, by the black soot that continually hung in the air, by the relentless ticking of factory time. They staged resistances with Romanticism, with the Gothic, with medievalism, with Catholicism, with Mesmerism, with Revivalism, with Pre-Raphaelitism, with Arts and Crafts, with Spiritualism, with ghosts, with fairies. The call went out to reenchant the world and our "St. George" became a knight-errant in that courtly crusade.[99] His holy fools were always out in front, with golden banners unfurled. "Rob of the Angels" was so gullible as to believe every word of every story "of ghosts and of the second sight" that he ever heard.[100] The more one muses upon it, however, the more one begins to wonder if perhaps Rob's surfeit of belief is better than the kind of person who grows more and more skeptical until he "comes at length to believe in nothing but his dinner." Curdie "was getting rather stupid—one of the chief signs of which was that he believed less and less in things he had never seen."[101] Diamond, another holy fool, believes so much that they accuse him of having a tile loose. He replies cheerfully that perhaps that's how the light gets in.[102] The world is already enchanted, of course, but our task is to perceive it. For those who have eyes to see, all mirrors are magic mirrors.[103]

[99]For MacDonald being referred to as "St. George," see Greville MacDonald, *George MacDonald and His Wife*, 548.

[100]MacDonald, *What's Mine's Mine*, 147.

[101]MacDonald, *Princess and Curdie*, 12.

[102]MacDonald, *North Wind*, 251.

[103]MacDonald, *Visionary Novels*, 323. *Phantastes* was first published in 1858.

"'A fairy can believe anything that ever was or ever could be,' said the old man."[104] George MacDonald's goal, of course, was not to teach us to have faith in fairies, but to allow the fairies to teach us to have faith: "Even if wholly fictitious, a good story is always true."[105] MacDonald was making the same point in his delightful aphorism that it is not easy to lie when writing a work of fiction.[106] Or, as he teaches in one of his *Unspoken Sermons*, "True, all I have been saying is imaginary; but our imagination is made to mirror truth; all the things that appear in it are more or less after the model of things that are . . . and when we are true it will mirror nothing but truth."[107] And again, as a Victorian sage:

> Let no one say I have been speaking in a figure merely. That I have been so speaking I know. But many things which we see most vividly and certainly are more truly expressed by using a right figure, than by attempting to give them a clear outline of logical expression.[108]

Diamond makes his earnest appeal, "I can't bear to find it a dream, because then I should lose you. . . . You aren't a dream, are you, dear North Wind?" To which she replies, "I'm either not a dream, or there's something better that's not a dream."[109] My friends, I assure you, it is not necessary for you to believe in the rosefire. But if it is a way of speaking in figures, a work of the human imagination, then there is something real that is like it, only better.

[104]MacDonald, *Gifts of the Child Christ*, I:146.
[105]MacDonald, *Adela Cathcart*, 85.
[106]George MacDonald to his daughter Lilia, 4 January 1891, *Expression of Character*, 343.
[107]MacDonald, *Unspoken Sermons*, 273.
[108]MacDonald, *Unspoken Sermons*, 151.
[109]MacDonald, *North Wind*, 309.

RESPONSE

JILL PELÁEZ BAUMGAERTNER

IN THE MIDST OF HIS USUAL ELEGANT, thorough, original, and downright interesting take on yet another subject in his vast array of "ways into" nineteenth-century thought, Dr. Larsen writes two sentences of clear resonance for poets. These sentences are: "His [MacDonald's] real dream was to be a poet." And "There were no salaried positions to be had for entry-level poets." Here is another story of just such a poet: Early in his life he was known for his love poetry, some of it scandalous. He eloped with a sixteen-year-old when he was twenty-nine. He lost his position at court and lived in penury until, finally, fourteen years and twelve children later he gave in and accepted the King's multiple invitations to take Anglican orders. He was, of course, John Donne. And many during his lifetime and afterwards have been critical of his decision to become a priest when there were no other options for him and he desperately needed the money. What if he had not given in to the pressure of the King and of penury? We would never have had twelve volumes of his extraordinary sermons. The Church of England would never have experienced a most original and spirit-filled Dean of St. Paul's Cathedral. Sometimes even the

very best need this kind of external pressure to encourage them to fully develop their God-given gifts.

NEEDED TROUBLES

I have often said to my poetry writing students eager to spend their lives writing poetry, "You can teach; otherwise, you should marry well." In MacDonald's case it was, as for Donne, a clear choice: either put on the clergyman's collar or let wife and children starve. Tim Larsen's speculation that in MacDonald's case there seems to be evidence of "self-loathing" because of his decision to enter the ministry seems well-founded. Growing a beard (when this was frowned upon for clergy), mocking his parishioners, denouncing a congregation listening to him preach—he sounds like every church's nightmare of a pastor. And yet he demonstrated a high level of self-awareness, not only noting his own vanity and his pride but even to a certain point regretting it. As Dr. Larsen points out, MacDonald also said, "I for my part would not go without one of my troubles. I have needed every one."

In his definitive biography of MacDonald, Rolland Hein notes that after a performance of a play—probably *The Pilgrim's Progress*—MacDonald was approached by a woman who described a child who was kept from attending the play because of illness. MacDonald wrote on a scrap of paper and handed it to the woman, saying, "Give her that with my love." On the paper he had written,

Pain and sorrow
Plough and harrow,
For the seed its place to find;

For the growing
Still the blowing
Of the Spirit's thinking wind,
For the corn that it will bear,
Love eternal everywhere.[1]

The plow and harrow are painful. They cut into earth so that the seed may be planted and the corn may grow. In Hein's words, "He was unwavering in his conviction that all disappointments of good people will one day yield some further evidence of God's love."[2]

His convictions in this regard connect him with the best and strongest writers of the faith over the past two millennia. Reach back some mere five hundred years to Luther, who writes in *Table Talk*, "God has taken hold of me rather severely, and I have been impatient too, exhausted by so many and such violent sicknesses. But God knows better than we which purpose they serve. Our lord God resembles a typesetter, who set his letters backwards. We definitely see and feel that He is setting His type, but the print we shall see in the beyond. Meanwhile we must have patience."[3]

Why am I referring to Luther in relation to MacDonald's ideas and not to Calvin? After all, MacDonald's family was deeply rooted in Calvinism. But his resistance to strict Calvinist theology has been well documented. Less known is the fact that MacDonald's poetry includes his English translations of Luther's hymns,

[1]Rolland Hein, *George MacDonald: Victorian Mythmaker* (Nashville, TN: Star Song, 1993), 317.
[2]Hein, *George MacDonald*, 317.
[3]Martin Luther, *What Luther Says: An Anthology*, ed. Ewald M. Plass, 3 vols. (St. Louis: Concordia, 1959), 2:1025.

published in 1876 under the title *Exotics*, which also included translations of Schiller, Novalis, Goethe, and others. So it is clear that Luther's theology as expressed in his hymns was, if not close to MacDonald's heart, then at least considered by him to be worthy of serious consideration. Did he know that for Lutherans, hymns *are* theology? This is a promising topic for scholarly exploration. After all, anyone who would say, as MacDonald did, that bad theology leads to death would probably be quite at home with Luther. For Luther's most well-known hymn, "A Mighty Fortress is Our God," MacDonald offered the following translation:

> Our God he is a castle strong,
> A good mail-coat and weapon
> He sets us free from every wrong
> That wickedness would heap on.
> The ancient wicked foe
> He means earnest now;
> Force and cunning sly
> His horrid policy,
> On earth there's nothing like him.[4]

Macdonald's translations are in the main both literal and un-singable, not to rival any of the translations that have been used in Protestant churches since the nineteenth century. But the "mail-coat and weapon" necessary for the fervent believer spoke strongly to MacDonald, who understood the place of suffering in the Christian life. And in this respect, he shares insights and

[4]George MacDonald, *Exotics, a Translation of the Spiritual Songs of Novalis, the Hymn-book of Luther, and Other Poems from the German and Italian* (London: Strahan, 1876), 66.

experiences with other well-known writers—for example, once again, John Donne:

So, in his purple wrapp'd receive mee Lord,
By these his thornes give me his other Crowne;
And as to others soules I preach'd thy word,
Be this my Text, my Sermon to mine owne,
Therefore that he may raise the Lord throws down.[5]

And John Donne on this subject leads me in a circuitous path to Richard John Neuhaus's *As I Lay Dying—Meditations upon Returning*, a response to Donne's meditations when Neuhaus thought he was dying:

There is nothing that remarkable in my story, except that we are all unique in our living and dying. Early on in my illness a friend gave me John Donne's wondrous *Devotions upon Emergent Occasions*. The *Devotions* were written a year after Donne had almost died and then lingered for months by death's door. He writes, "Though I may have seniors, others may be elder than I, yet I have proceeded apace in a good university, and gone a great way in a little time, by the furtherance of a vehement fever." So I too have been to a good university, and what I have learned, what I have learned most importantly, is that, in living and in dying, everything is ready now.[6]

The vehement fever, Christ's crown of thorns, the best university. "Pain and sorrow/Plough and harrow/for the seed its place to

[5]John Donne, "Hymne to God My God, in My Sicknesse," in *The Complete English Poems of John Donne*, ed. C. A. Patrides (London: Dent, 1985), 489.
[6]Richard John Neuhaus, *As I Lay Dying: Meditations upon Returning* (New York: Basic Books, 2002), 167.

find." And then there is Flannery O'Connor and her understanding of suffering, derived from lupus, the disease that finally killed her: "In a sense sickness is a place, more instructive than a long trip to Europe, and it's always a place where there's no company, where nobody can follow. Sickness before death is a very appropriate thing and I think those who don't have it miss one of God's mercies."[7] For all of these faithful writers, the understanding is this: suffering prepares, suffering teaches, suffering purges—and that leads to a consideration of Dr. Larsen's discussion of purgatory.

THE CONSUMING FIRE

Here is what is different about MacDonald, as Dr. Larsen presents him: MacDonald says, "We are in this world in order to become pure." I doubt that Luther would put it this way. But that doesn't necessarily mean he would disagree. He intimately links sanctification and justification. But, he cautions, holiness cannot be sought apart from justification. In one of his essays Luther wrote, "I find in the Scriptures, indeed, that Christ, Abraham, Jacob, Moses, Job, David, Hezekiah, and some others tasted hell in this life. *This I think to be purgatory*, and it is not incredible that some of the dead suffer in like manner."[8]

There are echoes of purgatorial fire in MacDonald's rosefire. "The Consuming Fire," a sermon MacDonald published in his

[7]Flannery O'Connor, *The Habit of Being*, ed. Sally Fitzgerald (New York: Farrar, Straus and Giroux, 1979), 163.

[8]"Works of Martin Luther—An Argument—In Defense of All the Articles of Dr. Martin Luther Wrongly Condemned in the Roman Bull Jesus," GodRules.net/BibleExplore.com, www.godrules.net/library/luther/NEW1luther_c4.htm. Emphasis mine.

Unspoken Sermons, has as its text Hebrew 12:29: "Our God is a consuming fire." MacDonald refers to the fire of the burning bush where God was revealed to Moses, a bush burning but not consumed. And then he says that

> the same symbol employed by a writer of the New Testament [that is, this verse from Hebrews] should mean more, not than it meant before, but than it was before employed to express; for it could not have been employed to express more than it was possible for them to perceive. What else than terror could a nation of slaves, into whose very souls the rust of their chains had eaten, in whose memory lingered the smoke of the fleshpots of Egypt, who, rather than not eat of the good they like best, would have gone back to the house of their bondage—what else could such a nation see in that fire than terror and destruction?

He goes on to say that the fire and smoke of Sinai

> was a revelation, but a partial one; a true symbol, not a final vision. . . . Here was a nation at its lowest: could it receive anything but a partial revelation, a revelation of fear? How should the Hebrews be other than terrified at that which was opposed to all they knew of themselves, beings judging it good to honor a golden calf?

He continues, "The intention was that so the stupid people . . . might leave a little room for that grace to grow in them, which would . . . make them see that evil, and not fire, is the fearful thing." And then MacDonald talks about what happens to those who "resist the burning of God, the consuming fire of Love." Those will be "cast into the outer darkness" which he describes as "fire

without light—the darkness visible, *the black flame*. And he asks God, our Consuming Fire, to burn us.[9] Dr. Larsen points out that MacDonald believes that without holiness we will not see God—that our call is to pursue holiness and sanctification. And my Lutheran answer is—well, we cannot pursue it. We can accept it as it is freely given to us through Christ and respond in gratitude with good works.

In one of the hymns that MacDonald translated from Luther we find this:

> Come Holy Spirit, lord and God, Fill full with thine own
> > gracious good
> Thy faithful ones heart, mind, desire;
> In them light of thy love the Fire.
> Thy holy fire, thy comfort sweet
> Now help us glad with cheer complete,
> That in thy service nought shake us,
> Trouble never from thee take us.
> O Lord by thy power us prepare,
> And make the weak flesh strong to bear
> That we wrestle like Knights gaining,
> Through death and life unto thee straining.[10]

The holy fire leads to comfort leads to cheer leads to service. Works are the outcome of grace.

The consuming fire, the rosefire, the rose itself permeate Mac-Donald's work, as Dr. Larsen has pointed out, which leads to

[9]George MacDonald, "The Consuming Fire," in *George MacDonald: Creation in Christ*, ed. Rolland Hein (Wheaton, IL: Harold Shaw, 1976), 157-66. Emphasis mine.
[10]MacDonald, *Exotics*, 57-58.

another connection with another poet he greatly admired. He had in his library several works of Blake and a copy of a biography of Blake.[11] How different from Blake's sick rose, however, is the effect of rosefire—but how clear in Blake the possibility of being overtaken by the black flame.

The Sick Rose
O Rose thou art sick.
The invisible worm,
That flies in the night
In the howling storm:
Has found out thy bed

Of crimson joy:

And his dark secret love
Does thy life destroy.[12]

This rose, its heart eaten out by the worm buried inside it, contrasts with the rose with fire within. Blake's rose is sick; MacDonald's alive and burning, and it hurts but it does not destroy life. It gives life.

THE WAY TO REALITY

Rolland Hein points out that while MacDonald admired Blake, his method differs considerably from Blake's. MacDonald felt that allegory was a particular challenge for the artist and that Blake was an allegorist. MacDonald writes, "He must be an artist indeed who can, in any mode, produce a strict allegory that is not a

[11]Hein, *George MacDonald*, 120.
[12]William Blake, *Songs of Innocence and of Experience* (Oxford: Oxford University Press, 1970), 147.

weariness to the spirit." Hein writes, "MacDonald's symbolism is largely impervious to the intellectual analysis that allegory demands, possessing rather an open-ended imaginative appeal that defies easy interpretation and yet seems to convey so intensely truths for which the human spirit yearns." Hein goes on to quote MacDonald: "A fairy tale, like a butterfly or a bee, helps itself on all sides, sips at every wholesome flower, and spoils not one." Hein notes that MacDonald compares the fairy tale to the sonata "because its metaphors are 'sufficiently loose' and present themselves with 'suitable vagueness.'"[13]

Dr. Larsen refers to Frederick Buechner's contention that fairy tales are essentially "eschatological." I know of no one who describes the phenomenon so alive in MacDonald's fantasies better than Buechner, even though he was not referring directly to MacDonald but to the way the gospel works.

And as for the king of the kingdom himself, whoever would recognize him? He has no form or comeliness. His clothes are what he picked up at a rummage sale. He hasn't shaved for weeks. He smells of mortality. We have romanticized his raggedness so long that we can catch echoes only of the way it must have scandalized his time in the horrified question of the Baptist's disciples, "Are *you* he who is to come?" (Matt. 11:13); in Pilate's "Are you the king of the Jews?" (Matt. 27:11) you with pants that don't fit and a split lip; in the black comedy of the sign they nailed over his head where the joke was written out in three languages so nobody would miss the laugh.

[13]Hein, *George MacDonald*, 402.

But the whole point of the fairy tale of the Gospel is, of course, that he is the king in spite of everything. The frog turns out to be the prince, the ugly duckling the swan, the little gray man who asks for bread the great magician with the power of life and death in his hands, and though the steadfast tin soldier falls into the flames, his love turns out to be fireproof. There is no less danger and darkness in the Gospel than there is in the Brothers Grimm, but beyond and above all there is the joy of it, this tale of a light breaking into the world that not even the darkness can overcome.

That is the Gospel, this meeting of darkness and light and the final victory of light. That is the fairy tale of the Gospel with, of course, the one crucial difference from all other fairy tales, which is that the claim made for it is that it is true, that it not only happened once upon a time but has kept on happening ever since and is happening still.[14]

For MacDonald the fairy tale was the way into reality; the imagination the way into the truth; the hurt of the rosefire filled with the fragrance of flowers the connection with divine love, the connection with light breaking into the world through the gospel.

[14]Frederick Buechner, *Telling the Truth: The Gospel as Tragedy, Comedy, and Fairy Tale* (San Francisco: Harper & Row, 1977), 90.

CONTRIBUTORS

Timothy Larsen (PhD, University of Stirling) is McManis Professor of Christian Thought at Wheaton College. He is a fellow of the Royal Historical Society, and he has been a visiting fellow at Trinity College, Cambridge, and All Souls College, Oxford. He is the author of a number of books, including *John Stuart Mill: A Secular Life*, *The Slain God: Anthropologists and the Christian Faith*, *A People of One Book: The Bible and the Victorians*, and *Crisis of Doubt: Honest Faith in Nineteenth-Century England*.

James Edward Beitler III (PhD, University of Michigan) is associate professor of English at Wheaton College. Dr. Beitler's primary areas of academic interest include rhetorical theory and criticism, composition pedagogy, writing program administration, and community-based writing. He is the author of *Remaking Transitional Justice in the United States: The Rhetorical Authorization of the Greensboro Truth and Reconciliation Commission*.

Richard Hughes Gibson (PhD, University of Virginia) is associate professor of English at Wheaton College. He is the author of *Forgiveness in Victorian Literature*.

Jill Peláez Baumgaertner (PhD, Emory University) is professor emerita of English and formerly dean of the humanities and theological studies at Wheaton College. She is the author of *Flannery O'Connor: A Proper Scaring* and several volumes of poetry, including *What Cannot Be Fixed*, *Finding Cuba*, and *Leaving Eden*. In 2001, she wrote a commissioned poem for the dedication of the Wade Center's new building titled "Where Words Regain Their Meaning."

AUTHOR INDEX

Alighieri, Dante, 86, 112, 119

Augustine, 93, 115-16

Blake, William, 133-34

Buechner, Frederick, 116-17,
134-35

Chesterton, G. K., 2, 30, 74

Coleridge, Samuel Taylor, 64, 87

Dale, R. W., 13-14

Dickens, Charles, 13, 20, 32

Donne, John, 125-26, 129

Eliot, T. S., 6-9, 121

Gore, Charles, 14-15

Hein, Rolland, 16, 126-27, 133-34

Hilton, Boyd, 12-13, 37, 39-40, 51

King, Jr., Martin Luther, 8

Lewis, C. S., 2-3, 5, 39, 73

Luther, Martin, 127-28, 130, 132

MacDonald, George
childhood, 12, 20, 62
life, 14-17, 21-26, 30-33, 56,
104-6, 110, 127-28
old age, 73, 120-21
pastorate, 13, 18, 81, 96-101
writings
Adela Cathcart, 11-12, 29,
34-36, 98, 106-8, 119, 123

Annals of a Quiet Neigh-
borhood, 22-23, 61, 69, 73,
101, 107, 109

At the Back of the North Wind,
29, 56, 75, 104, 112

David Elginbrod, 18-19, 31, 60,
69, 103, 107, 117

Diary of an Old Soul, 23, 28,
76, 79, 105, 113

Disciple, and Other Poems,
The, 60, 78

Dish of Orts, A, 24, 41, 56, 84

Donal Grant, 118

Gifts of the Christ Child,
Fairytales and Stories for the
Childlike, The, 26-30, 102, 123

Hope of the Gospel, The, 67

Light Princess and other Fairy
Stories, The, 35, 54, 106

Lilith, 20, 30, 43, 59, 61, 68, 73,
102, 115-16, 119

Miracles of our Lord, The, 16,
55, 59, 66, 71-72, 77-78, 101,
104, 11

Phantastes, 34, 39-45, 76-77,
103, 117

Princess and Curdie, The,
52-53, 75-77, 95-96, 113, 120,
122

Princess and the Goblin, The,
16, 53-54, 76, 95-96, 102

*Poetical Works of George
MacDonald, The,* 23-26, 30

Robert Falconer, 19, 33, 57,
61-63, 65-66, 68, 70, 76, 78,
114, 117

Seaboard Parish, The, 85-86

Thomas Wingfold, Curate,
49-50, 53-55, 67, 69-72, 74,
78-81, 84, 98, 104, 107, 112,
118

*Unspoken Sermons: Series I, II,
and III,* 9, 24, 28-29, 31,
58-59, 70-71, 76-77, 79,
112-115, 117, 120, 123, 131

*Visionary Novels of George
MacDonald, The,* 20, 30, 59,
61, 68, 73-74, 76-77, 102-3,
115-16, 118-19, 122

What's Mine's Mine, 19-20, 53,
57-58, 63, 65, 65-68, 78, 103,
111, 117, 122

Wilfrid Cumbermede, 53-54,
56-57, 60, 63-64, 68, 98,
116-117

Within and Without, 21-22, 31,
34, 54, 62-64, 78-79, 105,
108-9, 112-13

Maurice, Frederick Denison,
15-17, 21, 37, 41

Mill, John Stuart, 74

Neuhaus, Richard John, 129

O'Connor, Flannery, 130

Prickett, Stephen, 40-41, 43-45

Ruskin, John, 15-16, 80

Shelley, Percy Bysshe, 56, 64,
83-84, 91

Tennyson, Alfred Lord, 54-56,
83-84, 91

Tolkien, J. R. R., 2-4, 88

Twain, Mark, 56

Wordsworth, William, 64, 87-89

SUBJECT INDEX

afterlife, 39, 110-12
atheism, 56, 61, 65, 76
atonement, 15, 17-19, 24, 40, 115
 Age of, 12, 18-19, 62, 68
Calvinism, 20, 101, 127
Christmas, 11-12, 20-36
creation, 85-93
death, 110, 115
divine providence, 101-02
doubt, 50-61, 66-67, 69-70, 74-81,
 83-84, 91
 Age of, 50, 59
evangelicalism, 13-14, 52
fairies, 34-36, 102, 115, 122-23
fairy tales, 34-36, 41, 75, 92, 108,
 116-17, 134
faith, 13-15, 19, 28-29, 42-44,
 49-62, 65-68, 72, 75, 77-81,
 83-85, 101, 108, 123, 127
fantasy, 35, 43-45, 73, 77, 117
ghost stories, 32, 37-38
God, 8-9, 13, 18-19, 28-31, 46-47,
 57, 61-68, 78-79, 85-93, 101,
 103, 105-6, 108-9, 111-15, 119-21,
 127, 131-12
gospel, 13, 15, 81, 116-17, 134-35

Gospels, 69-74
holiness, 108-9, 111-12, 118, 130,
 132
Holy Spirit, 6-8
hope, 4, 6, 8, 29-30, 42, 61, 66-67,
 72, 81, 102, 108, 110-11, 120
imagination, 39, 41, 45, 85-93,
 123, 135
incarnation, 13-21, 28
 Age of, 12, 18, 20, 28
Jesus, 8, 15, 25, 27-28, 30-31, 62,
 66-67, 69-70, 72, 74, 77-81, 86,
 104, 110, 114-15, 118
justification, 24, 130
love, 6, 8-9, 13, 19, 28, 63-66, 88,
 112-114, 119, 131-33
Lux Mundi, 14-15
metaphor, 89-90, 134
nature, 31, 35, 41, 43, 45-46
Nature, 63-64, 69, 86, 88-89,
 92-93, 118
obedience, 66, 77-80, 118, 121
pentecostal/purifying/rosefire,
 5-7, 9, 95-96, 101, 113, 119, 123,
 130, 132-33, 135
Platonism, 45-46

poetry, 8-9, 23, 27, 64, 83-93,
117-18, 125-27
Protestant, 30, 51, 65, 111, 114,
punishment, 13, 17-19, 53, 108, 113,
120
Purgatory, 111, 130
reality, 4-5, 29, 45, 111, 133-35
redeem/redeemed/redemption,
6-8, 114-15, 119
Reenchantment of the World,
95-135
romantic, 61-65, 84, 92-93, 118, 122
roses, 6, 95-96, 117-119, 121, 132-33
sanctification, 30, 96, 104, 108-10,
112, 114, 119, 121, 130, 132

sin, 6-7, 14, 18, 96, 98, 108, 111-16,
120
spiritual, 14, 18-19, 26-27, 29, 40,
45, 53, 58, 61-69, 73-74, 96,
105-8
suffering, 103-06, 115, 120, 128,
130
symbol, 46, 92, 119, 131, 134
theology, 9, 17, 19, 62, 67,
87-88, 97, 101, 107, 110, 118,
127-28
trust, 9, 44, 66, 75-81, 104, 106
Victorian Age, 13-17, 20-21, 25,
31-34, 38, 50-52, 54, 57, 61-62,
74, 80, 122-23

SCRIPTURE INDEX

OLD TESTAMENT

Job
13:15, *106*

Psalms
22:6, *119*
30:5, *74*
34:8, *79*
59:13, *68*
119:71, *106*
139:21, *68*

Isaiah
1:13, *100*
30:15, *73*
53:1, *76*

Lamentations
3:1, *68*

Amos
5:21, *100*

NEW TESTAMENT

Matthew
5:48, *114*
19:14, *29*

Mark
9:24, *59*

Luke
4:18, *5*

John
1:9, *14*
7:17, *78*

10:9, *70*
20:31, *80*

Acts
2:1, *8*
2:38, *8*

Romans
11:29, *111*

1 Corinthians
2:2, *15*
13, *66, 84*

Hebrews
12:2, *67*
12:14, *111*
12:29, *112, 131*

The Marion E. Wade Center

Founded in 1965, the Marion E. Wade Center of Wheaton College, Illinois, houses a major research collection of writings and related materials by and about seven British authors: Owen Barfield, G. K. Chesterton, C. S. Lewis, George MacDonald, Dorothy L. Sayers, J. R. R. Tolkien, and Charles Williams. The Wade Center collects, preserves, and makes these resources available to researchers and visitors through its reading room, museum displays, educational programming, and publications. All of these endeavors are a tribute to the importance of the literary, historical, and Christian heritage of these writers. Together, these seven authors form a school of thought, as they valued and promoted the life of the mind and the imagination. Through service to those who use its resources and by making known the words of its seven authors, the Wade Center strives to continue their legacy.

THE HANSEN LECTURESHIP SERIES

The Ken and Jean Hansen Lectureship is an annual lecture series named in honor of former Wheaton College trustee Ken Hansen and his wife, Jean, and endowed in their memory by Walter and Darlene Hansen. The series features three lectures per academic year by a Wheaton College faculty member on one or more of the Wade Center authors with responses by fellow faculty members.

Kenneth and Jean (née Hermann) Hansen are remembered for their welcoming home, deep appreciation for the imagination and the writings of the Wade authors, a commitment to serving others, and their strong Christian faith. After graduation from Wheaton College, Ken began working with Marion Wade in his residential cleaning business (later renamed ServiceMaster) in 1947. After Marion's death in 1973, Ken Hansen was instrumental in establishing the Marion E. Wade Collection at Wheaton College in honor of his friend and business colleague.

Finding the Textbook You Need

The IVP Academic Textbook Selector
is an online tool for instantly finding the IVP books
suitable for over 250 courses across 24 disciplines.

ivpacademic.com